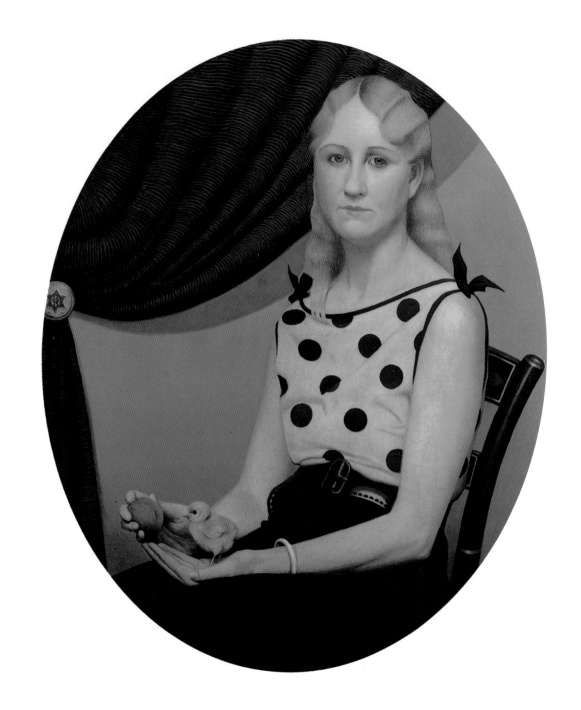

Plate 1
Portrait of Nan, 1933
Oil on Masonite panel, 34 ½ x 28 ½ in. (oval)
On loan to the Elvehjem Museum of Art, University of Wisconsin–Madison
Collection of William Benton

GRANT WOOD
AN AMERICAN MASTER REVEALED

Brady M. Roberts, James M. Dennis, James S. Horns, and Helen Mar Parkin

DAVENPORT MUSEUM OF ART
Pomegranate Artbooks · San Francisco

Published by Pomegranate Artbooks
Box 6099, Rohnert Park, California 94927

Pomegranate Europe Ltd.
Fullbridge House, Fullbridge
Maldon, Essex CM9 7LE, England

Pomegranate Catalog No. A819

Library of Congress Cataloging-in-Publication Data

Grant Wood : an American master revealed / Brady M. Roberts . . . [et al.].
 — 1st ed.
 p. cm.
 ISBN 0-87654-485-5
 1. Wood, Grant, 1891–1942—Exhibitions. 2. Wood, Grant,
1891–1942—Criticism and interpretation. I. Roberts, Brady M.
II. Davenport Museum of Art.
ND237.W795A4 1995
759.13—dc20 95-24186
 CIP

Designed by John Malmquist Design

Printed in Korea
00 99 98 97 6 5 4 3

First Edition

CONTENTS

Foreword . vii

Acknowledgments . viii

Lenders to the Exhibition . xi

The European Roots of Regionalism: Grant Wood's Stylistic Synthesis . 1
 by Brady M. Roberts

Grant Wood's Native-Born Modernism . 43
 by James M. Dennis

Grant Wood: A Technical Study . 67
 by James S. Horns and Helen Mar Parkin

Appendix A: Technical Study of Materials Comprising Fourteen Paintings by Grant Wood 92
 by James S. Martin

Appendix B: A Study of the Materials Used in Grant Wood's American Gothic . 96
 by Inge Fiedler

Plate List . 99

Chronology . 102

Exhibition Checklist . 103

The Authors . 108

Index . 109

EXHIBITION VENUES

This book was published in conjunction with the exhibition *Grant Wood: An American Master Revealed:*

Joslyn Art Museum
Omaha, Nebraska
December 10, 1995 – February 25, 1996

Davenport Museum of Art
Davenport, Iowa
March 23, 1996 – September 8, 1996

Worcester Art Museum
Worcester, Massachusetts
October 6, 1996 – December 31, 1996

The exhibition, an official Iowa Sesquicentennial Event, was organized by the Davenport Museum of Art with the generous support of the Riverboat Development Authority and additional support from the Iowa Arts Council and the fund-raising activities of the Friends of the Davenport Museum of Art, the Volunteer Guild, and the Beaux Arts Fund Committee, Inc.

FOREWORD

As we approach the close of the twentieth century, hardly a week goes by without a reminder of Grant Wood's hold on the popular imagination. Usually this reminder comes in the form of reproductions or parodies of Wood's major paintings that have served to identify him as this century's quintessential artist of Middle America. Yet in the face of this popularization of Wood's art, even students of American culture have tended to overlook the complexities of his personality and artistic vision. Now, more than fifty years after his death, it is fitting that we consider Grant Wood in the context of his artistic generation and the formative experiences that influenced him and so many other North American artists and writers born at the end of the nineteenth century.

This catalog and the traveling exhibition for which it was created take a new look at Grant Wood and his relation to modernism, that is, the stylistic innovations and experimental approaches to subject matter developed and practiced by European and American artists between roughly 1880 and 1925. They demonstrate that Wood's artistic vision did not develop in a midwestern vacuum but instead drew heavily on sources ranging from Georges Seurat to Neue Sachlichkeit to Arts and Crafts design principles.

The inspiration for this exhibition is the small group of plein air oil studies Wood created in Europe in the 1920s and later oil studies for major works in the collection of the Davenport Museum of Art. The majority of these works, as well as the museum's most important Grant Wood painting, *Self Portrait*, were acquired in 1965 from the artist's sister, Nan Wood Graham. Major paintings and their preparatory drawings and oil studies have also been borrowed from generous collectors and museums across the country, enabling the exhibition to demonstrate Wood's working methods and his dramatic stylistic shift after his fourth trip to Europe in 1928. To enhance this understanding, a team of conservators has prepared the first systematic technical examination of Grant Wood's paintings for this catalog.

We are grateful to all those who lent their significant works for this critical reevaluation of Wood's artistic career. An acknowledgments section and a list of lenders follow, but we would particularly like to thank James N. Wood, Director and President, and Charles F. Stuckey, Frances and Thomas Dittmer Curator of Twentieth-Century Painting and Sculpture, at The Art Institute of Chicago for the pivotal loan of *American Gothic*.

We would also especially like to acknowledge the work of Brady M. Roberts, the organizing curator at the Davenport Museum of Art, for his significant contribution to our understanding of this complex artist. We are also indebted to the art historian James M. Dennis; private conservators James S. Horns and Helen Mar Parkin; James S. Martin, Director of Analytical Services and Research at the Williamstown Art Conservation Center, Inc.; and Inge Fiedler, Conservation Microscopist at The Art Institute of Chicago.

Initiation of this project would not have been possible without the early support of the Riverboat Development Authority in Davenport, and promotion of the exhibition as a major event for the state of Iowa would not have succeeded without the enthusiastic endorsement of the Iowa Sesquicentennial Commission. As the state prepares to celebrate its 150th anniversary, it is our hope that this exhibition and publication will both celebrate and elucidate for a broad audience Iowa's favorite native son.

Wm. Steven Bradley, Director　　**Graham W. J. Beal, Director**　　**James A. Welu, Director**

Davenport Museum of Art　　**Joslyn Art Museum**　　**Worcester Art Museum**

ACKNOWLEDGMENTS

This catalog and exhibition would not have been possible without the generosity of the numerous private collectors and institutions who lent their prized works by Grant Wood. Many of the paintings provided by museums were subject to a "no loan" policy that was waived for this exhibition. We are deeply appreciative of this special consideration.

Several individuals provided sage advice on the organization of the exhibition and on the revisionist views presented in my essay. In particular, I would like to thank William C. Agee for his critical observations on Grant Wood in the broader context of developments in twentieth-century art and for his encouragement and support of this project from its earliest stages. I would also like to thank James M. Dennis for his important contribution to the catalog, insightful comments on my research, and assistance with the exhibition. James A. Maroney provided invaluable aid in locating major works in private collections, and Wanda M. Corn and Professor Robert Rosenblum offered erudite observations on my text.

James A. Welu, Director of the Worcester Art Museum (and a native Iowan), was extremely generous with his time, particularly with the organization of the first technical examination of Grant Wood's paintings. Graham W. J. Beal, Director, and Marsha V. Gallagher, Chief Curator, of the Joslyn Art Museum took an early interest in the approach to Grant Wood as a modernist and assisted with the development of this project in addition to bringing Grant Wood's major landscape painting, *Stone City, Iowa*, to the exhibition. We are delighted to have the Worcester Art Museum and the Joslyn Art Museum join the Davenport Museum of Art as venues for the exhibition.

The difficult task of performing the first systematic conservation examination of Grant Wood's paintings was undertaken by Helen Mar Parkin and James S. Horns on short notice. Their long hours of work and high degree of professionalism are greatly appreciated. James S. Martin, Director of Analytical Services and Research at the Williamstown Art Conservation Center, Inc., skillfully performed an extensive laboratory analysis of paint samples. Conservators from participating institutions also contributed their time and expertise. Our gratitude goes to Inge Fiedler and Timothy Lennon of the Conservation Department at The Art Institute of Chicago for their extensive research on *American Gothic*. Elizabeth Walmsley, Associate Conservator for Systematic Catalog, and Bonnie Wisniewski, Conservation Technician, at the National Gallery of Art graciously assisted with our inquiries. Also working on short notice with impressive results was Mark Tade, who photographed numerous works for the catalog from public and private collections in the Midwest.

Many individuals and institutions facilitated the loans for the exhibition. I would like to thank the following people for their cooperation: James N. Wood, Director and President, Charles F. Stuckey, Frances and Thomas Dittmer Curator of Twentieth-Century Painting and Sculpture, and Kate Heston, Secretary and Research Assistant, The Art Institute of Chicago; Debra J. Force, Director, Beacon Hill Fine Art; Peggy Boyle Whitworth, Executive Director, Brucemore, Inc.; Dr. John McCracken, Director, Carnegie-Stout Public Library, Dubuque; John C. Fitzpatrick, Program Facilitator, Fine Arts, Cedar Rapids Community School District; Joseph S. Czestochowski, Director, Cedar Rapids Museum of Art; Barbara K. Gibbs, Director, and Dr. John Wilson, Curator of Painting and Sculpture, Cincinnati Art Museum; John E. Brown, President, and John Beckelman, Chairman of the Art Department, Coe College, Cedar Rapids; Janelle V. McClain, Corner House Gallery; Hans Becherer, Chairman and Chief Executive Officer, Deere & Company, and Laurence F. Jonson, Corporate Curator, John Deere Art Collection; I. Michael Danoff, Director, and Margaret A. Willard,

Registrar, Des Moines Art Center; Harry S. Parker III, Director, Steven A. Nash, Associate Director and Chief Curator, and Patricia Junker, Assistant Curator of American Paintings, The Fine Arts Museums of San Francisco, M. H. de Young Memorial Museum; Bonnie Kirschstein, Associate Curator, The FORBES Magazine Collection, New York; Janet Farber, Associate Curator of Twentieth-Century Art, Ted James, Collections and Exhibitions Manager, and Penelope Smith, Registrar, Joslyn Art Museum; Rev. Francis A. Lana; Dr. and Mrs. R. W. Lengeling; Roland Augustine at Luhring Augustine Gallery; Phillipe de Montebello, Director, and Ida Balboul, Research Associate, Department of Twentieth-Century Art, The Metropolitan Museum of Art; Dr. Evan M. Maurer, Chief Executive Officer and Director, Minneapolis Institute of Arts; Earl A. Powell III, Director, Lisa E. Mariam, Loan Officer, and Anne Halpern, Staff Assistant, Curatorial Records and Files, National Gallery of Art; Dr. Elizabeth Broun, Director, and Dr. Virginia M. Mecklenburg, Chief Curator, National Museum of American Art; Mike Nickols of Nickols Fine Arts; Elyssa Kane, Associate Registrar, Pennsylvania Academy of the Fine Arts; Myron Kunin, President, and Vicki Gilmer, Executive Assistant, The Regis Collection, Inc.; Nicholas B. Bragg, Executive Director, and Ellen Kutcher, Collections Manager, Reynolda House Museum of American Art; George W. Neubert, Director, and Daphne Deeds, Curator and Assistant Director, Sheldon Memorial Art Gallery and Sculpture Garden, University of Nebraska–Lincoln; Dara Mitchell, Director and Senior Vice President, and Susan Imbriani, Department of American Paintings, Drawings, and Sculpture, Sotheby's; Andrea S. Norris, Director, and Nancy A. Corwin, Curator of European and American Art, Spencer Museum of Art, The University of Kansas; Stephen Prokopoff, Director, Jo-Ann Conklin, Curator of Graphic Arts, and Pamela White Trimpe, Curator of Painting and Sculpture, The University of Iowa Museum of Art; Richard and Leah Waitzer; David A. Ross, Director and Chief Executive Officer, Anita Duquette, Manager of Rights and Reproductions, Ellin Burke, Assistant Registrar, Permanent Collection, Nancy McGary, Administrator of Collections and Exhibitions, and Nancy Roden, Head Cataloger and Head of Rights and Reproductions, Whitney Museum of American Art; Linda Shearer, Director, Williams College Museum of Art; Susan E. Menconi, Executive Vice President, Richard York Gallery; and several private collectors who wish to remain anonymous.

The staff of Pomegranate Artbooks, in particular Thomas Burke, Publisher, Jill Anderson, Managing Editor, and Pat Harris, Associate Editor, deserve credit for their excellent work on the catalog on a limited schedule. Thanks also go to Bob Panzer at VAGA (Visual Artists and Galleries Association, Inc.) for his assistance.

Finally, I would like to express my gratitude to everyone on the small but hard-working staff at the Davenport Museum of Art who helped make this exhibition and catalog possible. In particular, I wish to thank Wm. Steven Bradley, Director, for allowing me the freedom to pursue this project over the past two years and for shepherding the exhibition through to a successful conclusion; Jane Milosch, Assistant Curator, for her tireless attention to detail and assistance with the catalog and exhibition; Patrick Sweeney, Registrar, for handling the complicated arrangements for loans, shipping, and countless other details; Theresa Hoffmann, Research Assistant; and Amy Trimble, Intern.

—B. R.

LENDERS TO THE EXHIBITION

The Art Institute of Chicago

Helen Benton Boley, courtesy Elvehjem Museum of Art,
 University of Wisconsin–Madison

Carnegie-Stout Public Library, Dubuque, Iowa

Cedar Rapids Community School District, Cedar Rapids, Iowa

Cedar Rapids Museum of Art

Cincinnati Art Museum

Coe College

Davenport Museum of Art

John Deere Art Collection

Des Moines Art Center

The Fine Arts Museums of San Francisco,
 M. H. de Young Memorial Museum

The FORBES Magazine Collection, New York

Joslyn Art Museum

Rev. Francis A. Lana

Dr. and Mrs. R. W. Lengeling

George and Janelle McClain

The Metropolitan Museum of Art

Minneapolis Institute of Arts

National Gallery of Art

National Museum of American Art

Pennsylvania Academy of the Fine Arts

The Regis Collection, Inc.

Reynolda House Museum of American Art

Sheldon Memorial Art Gallery and Sculpture Garden,
 University of Nebraska–Lincoln

Spencer Museum of Art, The University of Kansas

The University of Iowa Museum of Art

Richard and Leah Waitzer

Whitney Museum of American Art

Williams College Museum of Art

Additional anonymous private collectors

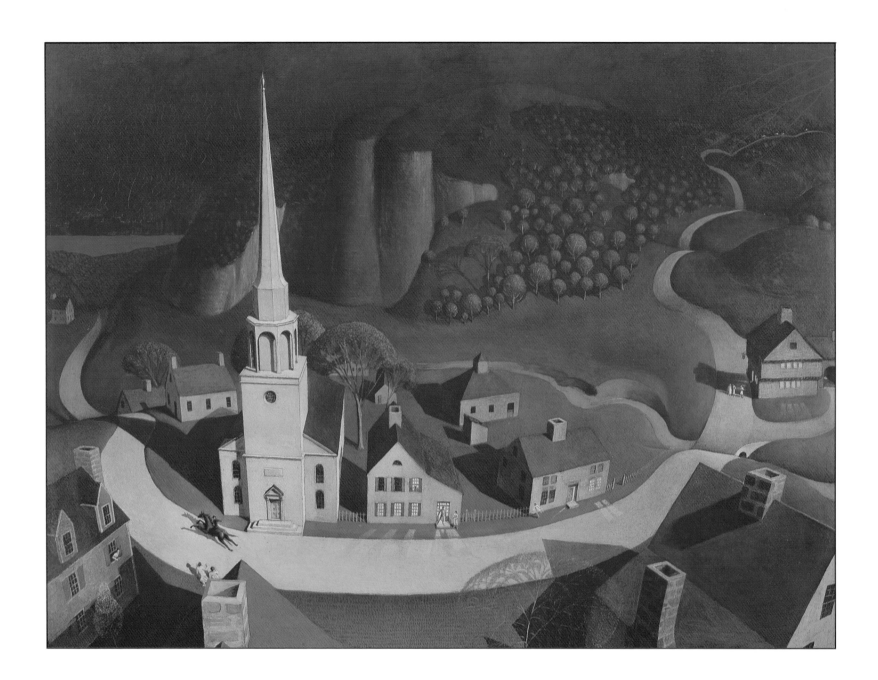

Plate 2
Midnight Ride of Paul Revere, 1931
Oil on composition board, 30 x 40 in.
The Metropolitan Museum of Art
Arthur Hoppock Hearn Fund, 50.117
© 1988 The Metropolitan Museum of Art

THE EUROPEAN ROOTS OF REGIONALISM: GRANT WOOD'S STYLISTIC SYNTHESIS

BY BRADY M. ROBERTS

Our theory being that when a painter has a definite message, he will, by experiment, find the most adequate means of expressing it, let the result be as conservative, as eclectic or as radical as it may.

—Grant Wood, "The Aim of the Colony,"

pamphlet for Stone City Colony and Art School, 1932

Concurrent with the widespread isolationist sentiment in America during the Great Depression of the 1930s, Regionalism gained popularity as a national school of painting. The triumvirate of Regionalism, Grant Wood, Thomas Hart Benton, and John Steuart Curry, concocted scenes of farm life and American folklore in a widely accessible, representational style that was viewed by critics as a reaction against the European domination of American art. Ironically, the three artists, who helped perpetuate this critical interpretation, all had formative experiences as art students in Paris and borrowed freely from European sources.

Scholarship has revealed the effect of Synchromism on the mature compositions of Thomas Hart Benton,[1] in addition to his expressive, El Greco–like attenuation of forms. Similarly, John Steuart Curry favored Michelangelesque figures in Baroque-inspired compositions for his best-known Regionalist paintings, such as *The Tragic Prelude* (1937–1942), his heroic portrait of John Brown.[2] Scholars have discussed the influence of Northern Gothic portraiture on Wood and have touched on modernist influences, particularly noting elements of simplified Art Deco design[3] and Neue Sachlichkeit painting in his work.[4] However, the lasting influence of early modern French painting on Wood following his three trips to Paris in the 1920s has not been adequately addressed.

A new reading of the visual text demonstrates Wood's appropriation of Georges Seurat's pointillist brushwork and classical form. Drawings, *croquetons* (small plein air sketches), and Seurat's major monument, *Un dimanche à la Grande Jatte* (A Sunday afternoon on the island of La Grande Jatte), are evident sources of influence on the studies and finely finished works of Wood's mature style. When considered in the broader context of European sources, this connection permits a fuller appreciation of Wood's complex stylistic synthesis.

Divisionist Painting and Classical Form: Wood's Seurat-Inspired Style of the 1930s

During the 1920s, Grant Wood traveled to Paris on three occasions, experimenting with Impressionist and Post-Impressionist styles of painting. On his first trip, in the summer of 1920, he accompanied Marvin Cone, an artist friend from his hometown of Cedar Rapids, Iowa, who spoke French, unlike Wood. Postcards from Wood to his mother and his sister, Nan, indicate that he worked on plein air paintings assiduously, even in rainy weather. Toward the end of his first trip, he wrote, "My stay seems like a dream."[5]

Wood took a sabbatical from teaching in the Cedar Rapids public schools and borrowed money to return to Europe for fourteen months in

1923–1924. He stayed primarily in Paris, studying at the Académie Julian, the Parisian art academy for foreign students, in the fall. He then traveled to Sorrento, Italy, with other artists in the winter months and returned to northern France and Paris to work on plein air paintings in the spring and summer of 1924. The artist again traveled to Paris in the summer of 1926. It was during these formative years that Wood developed his practice of plein air painting, which would serve as the starting point for his major landscape paintings of the 1930s.

Although the artist was prolific during the 1920s, paintings such as *The Little Chapel Chancelade* (1926, Plate 5) demonstrate that his approach to Impressionism was rather heavy-handed, with none of the dissolution of form or color harmonies of Monet. A more daring painting, *The Grand Cascade Bois de Bologne, Paris* (1923, Plate 6), shows a higher degree of surface abstraction, with broad areas of intense color recalling Post-Impressionism or Fauvism, although the forms are still massive, lacking the refinement of French painting.

Wood's work in France culminated with an exhibition of thirty-seven paintings at the Galerie Carmine, Paris, in 1926. Few paintings were sold and there was virtually no critical response to the show, which the artist considered unsuccessful.[6] However, the significance of Wood's three trips to Paris cannot be underestimated. His experimentation with Impressionism and Post-Impressionism and his exposure to modern European art played a significant role in the development of his mature style.

An important work from these formative years is *The Spotted Man* (1924, Plate 8), an academic figure study rendered in a pointillist manner that Wood created while studying at the Académie Julian. Although the painting demonstrates little of the intense color interaction of Seurat's "scientific" color combinations inspired by the optical treatises of the nineteenth-century physicists Chevreul, Blanc, and Rood, this experiment with Neo-Impressionism established an approach to developing forms and compositions that remained with Wood throughout his mature period and resurfaced consistently in his late paintings.

A late oil-on-panel study, *Iowa Cornfield* (1941, Plate 3), recalls the *croquetons* Seurat made in preparation for major canvases. The subject, shocks of corn, is reminiscent of Monet's grainstack forms yet with a decidedly midwestern resonance. The subject is also comparable to one of the many Millet-inspired rural themes Seurat painted in the 1880s. In Seurat's *Le Cheval attelé* (1884, Figure 1), the sculptural horse is framed in with similarly reductive *repoussoir* trees. In contrast to the static arrangement of monumental forms, the brushwork consists of short horizontal strokes creating a crosshatching of separate touches of color that Seurat scholar William I. Homer described as a "shimmering union of color and chiaroscuro."[7] Wood used a similar method of optical mixing to create the vibrant corn shocks and fields of his plein air study *Iowa Cornfield*. The touches of turquoise, yellow-green, and white on peach and green fields combine to create brilliant but static forms, based on observation but enhanced through color interaction. Although it is unlikely that Wood was aware of the theoretical underpinnings of Seurat's Neo-Impressionism, he did employ similar stylistic techniques.

Like Seurat, Wood applied short horizontal brush strokes in a relatively loose and broad manner when creating crosshatched forms in his small plein air studies. Also like Seurat, as he developed his sketches into more

ambitious compositions, his brushwork became finer and the work more highly detailed. *Haying* and *New Road* of 1939, for instance, employ a finer crosshatching than is seen in the plein air sketch *Iowa Cornfield*.[8] A close examination of *Haying* (Plate 9) reveals a complex structure of thin horizontal brush strokes of gold, green, and white with mauve highlights and touches of violet and blue that, when viewed from a distance, pull together, creating stylized, reductive forms of a freshly harvested field. Although Wood used local colors instead of an intense combination of complementaries, the *mélange optique* creates a surface vibrancy approximating Seurat's pointillism.

The pendant painting *New Road* (Plate 10) exhibits similar pointillist tendencies, especially in the sky, rendered with a vibrant network of fine pink, red, and violet brush strokes on a blue background. It is noteworthy that Wood's earliest experimentation with Impressionism emphasized the broad, loose brushwork favored by Monet and his followers, but as his style matured, his innate sense of order and classical form drew him to the measured, calculated methods of Seurat.

Wood's apparent appropriation of Seurat's divisionist method of crosshatching to render vibrant, classically reductive forms can be seen again in the preparatory study and finished version of *Spring Turning* (1936, Figure 2, Plate 4). In the full-sized preliminary drawing, Wood created a series of fine crosshatching marks, allowing the brown of the paper to blend with the green and blue-gray shading of the hills. The effect anticipates the finished version of the work, in which a delicate crosshatching of light and dark green brush strokes activates the surface of the painting, enhancing the lush beauty of the stylized landscape and transcending naturalistic description.

In 1933, Wood began work on the design for one of his most ambitious expressions as a Regionalist painter, *Dinner for Threshers* (Figure 3, Plate 11). Completed in 1934, the large-scale painting, which Wood conceived of as a mural, depicts the agrarian midwestern institution of communal dining during the threshing season.[9] At harvest time, cooperative threshing increased farm efficiency and played an important social role, especially for single people, who enjoyed the opportunity to gather and get acquainted.[10] Wood's celebration of the event portrays farmers seated at the midday meal, which is being prepared and served by women in the kitchen. Outside, younger men and hired hands wait for an available seat as older men and family members are served first. As Wanda Corn notes, the cutaway view of the farmhouse and arrangement of figures around the table recalls trecento paintings of the Last Supper.[11] Yet the classically reduced figures arranged in a frieze-like procession also have more modern associations, specifically recalling Seurat's *Un dimanche à la Grande Jatte* (1884–1886, Figure 4).

La Grande Jatte, Seurat's *grande machine* of contemporary Paris, combined Antique allusions with the most advanced scientific theories of color and design to create a modern classical frieze. In describing the work, Seurat said, "The Panathenaens of Phidias formed a procession. I want to make modern people, in their essential traits, move about as they do on those friezes."[12] Toward that end, Seurat prepared numerous plein air oil sketches and drawings of Parisians enjoying their leisure time on the idyllic and popular island park. These studies were the basis for studio compositions in which the artist arranged sculptural forms in a static composition emphasizing horizontal and vertical accents. Seurat maintained

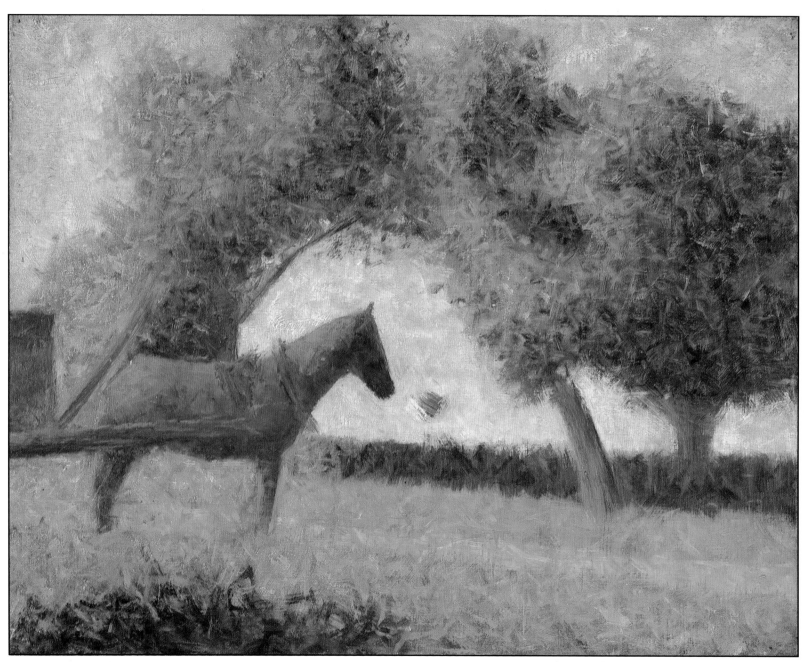

1 Georges Seurat (French, 1859–1891)
Le Cheval attelé (Harnessed horse), 1884
Oil on canvas, 13¾ x 16⅛ in.
Solomon R. Guggenheim Museum, New York
Gift of Solomon R. Guggenheim, 1941, 41.722
Photograph by David Heald, © The Solomon R.
Guggenheim Foundation, New York

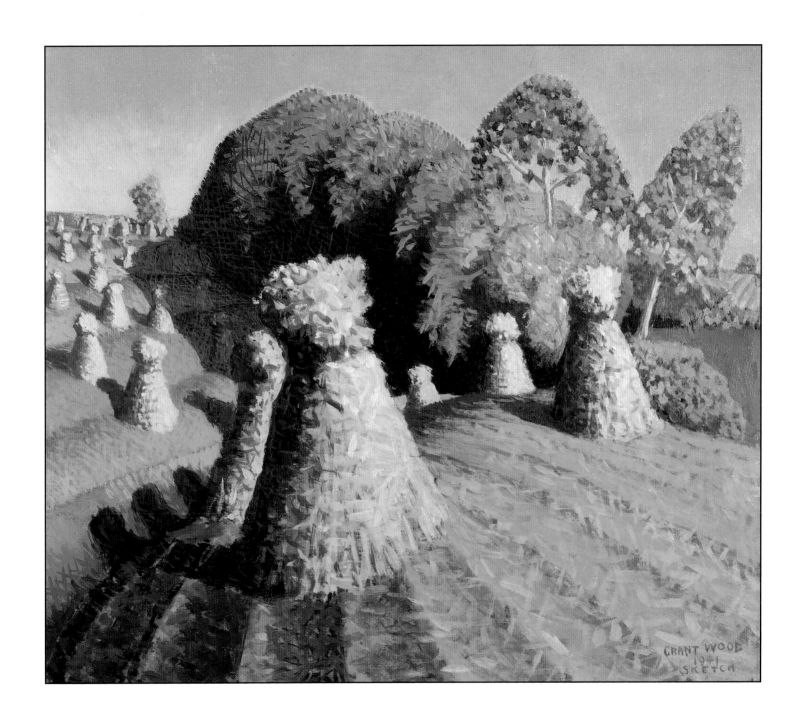

Plate 3
Iowa Cornfield, 1941
Oil on Masonite panel, 13 x 15 in.
Davenport Museum of Art, 60.1013

that upward lines evoke gaiety, whereas horizontal lines create a sense of calmness; he combined both in *La Grande Jatte* to form the grandeur of a classical frieze.[13]

This Antique emphasis also reflects a renewed interest in early Renaissance painting, particularly the work of Piero della Francesca, around the time Seurat studied at the École des Beaux-Arts, from 1878 to 1879.[14] His incorporation of Piero's style in the frieze-like *La Grande Jatte* is comparable to the classicism of Wood's later painting *Dinner for Threshers.* Piero-like elements in both works include precisely contoured figures reduced to geometric forms in a calculated composition emphasizing horizontal and vertical lines, alluding to the format and figuration

of Antique friezes.[15] Both Seurat and Wood started with direct observation but then transcended the particular in an attempt to achieve universal stability. Their classicism began with reductive preparatory drawings (Figures 5 and 6).

It is not surprising that the critical and popular reception for *La Grande Jatte* and *Dinner for Threshers* was similar, with both works admonished for what was perceived as a peculiarly stiff lack of realism. When displayed at the Eighth Exhibition of the Impressionists, Seurat's human forms were dismissed as "poorly articulated wax figures." His work was also called "wooden, naively modelled," and "highly mannered . . . lifeless . . . seduced by external formulas."[16]

Dinner for Threshers garnered comparable comments from readers of *Time* magazine in 1935, when the work was reproduced for an article about the Carnegie International Exhibition of Art. Given the opportunity to respond to accusations that he was unable to draw realistic detail, Wood snapped back with regard to his reductive method: "My paintings have a basis of design with simplification and various qualities which the reader would not understand."[17] Edward Alden Jewell, art critic for the *New York Times,* had more prescient observations than did the contributors to *Time* in his glowing review of the work. At length, Jewell compared Wood's painting with the murals of Giotto, recognizing the artist's tendency toward modernist classicizing.[18] Similarly, Seurat's sources and intentions had been better

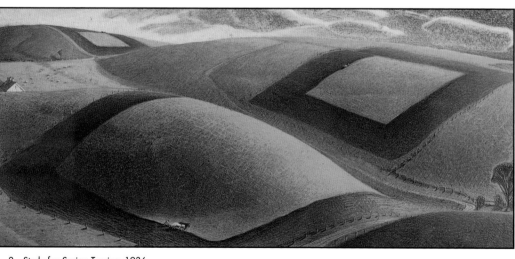

2 Study for *Spring Turning*, 1936
Pencil, charcoal, and chalk on paper, 17 ½ x 39 ¾ in.
The Henry E. Huntington Library and Art Gallery, San Marino, California
Gift of the Virginia Steele Scott Foundation, 83.8.53
(Not in exhibition)

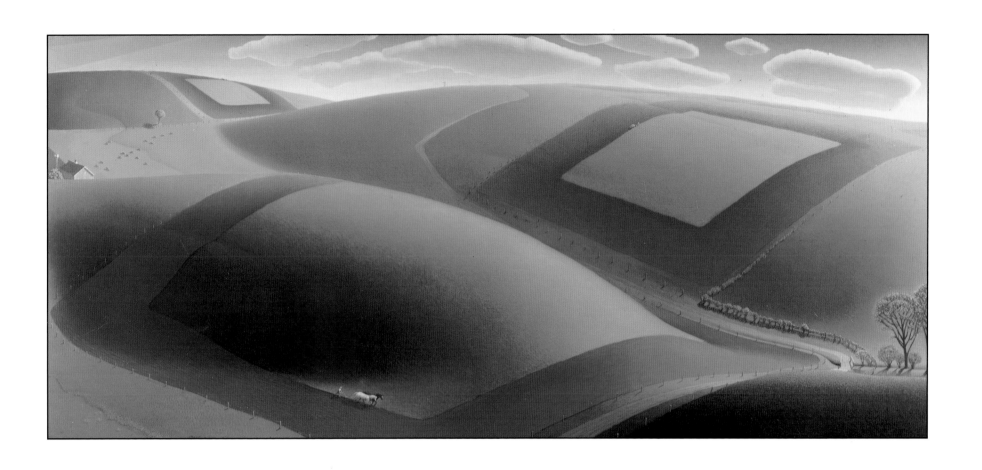

Plate 4
Spring Turning, 1936
Oil on Masonite panel, 18 ¼ x 40 ¼ in.
Reynolda House Museum of American Art, Winston-Salem, North Carolina
Gift of Barbara B. Millhouse

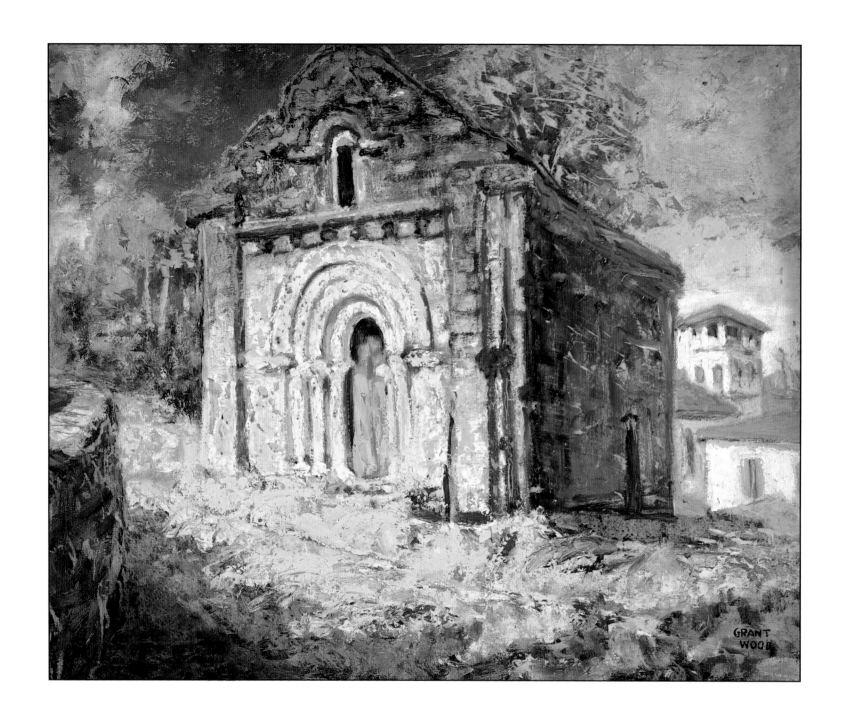

Plate 5
The Little Chapel Chancelade, 1926
Oil on composition board, 13 x 16 in.
Davenport Museum of Art, 65.6

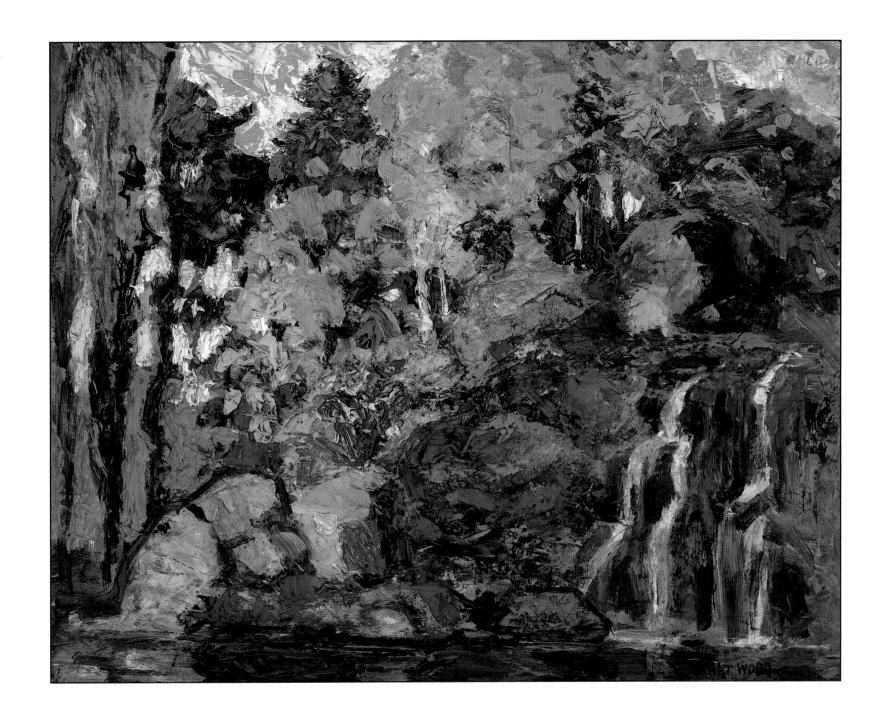

Plate 6
The Grand Cascade Bois de Bologne, Paris, 1923
Oil on composition board, 13 x 15 in.
Collection of Rev. Francis A. Lana

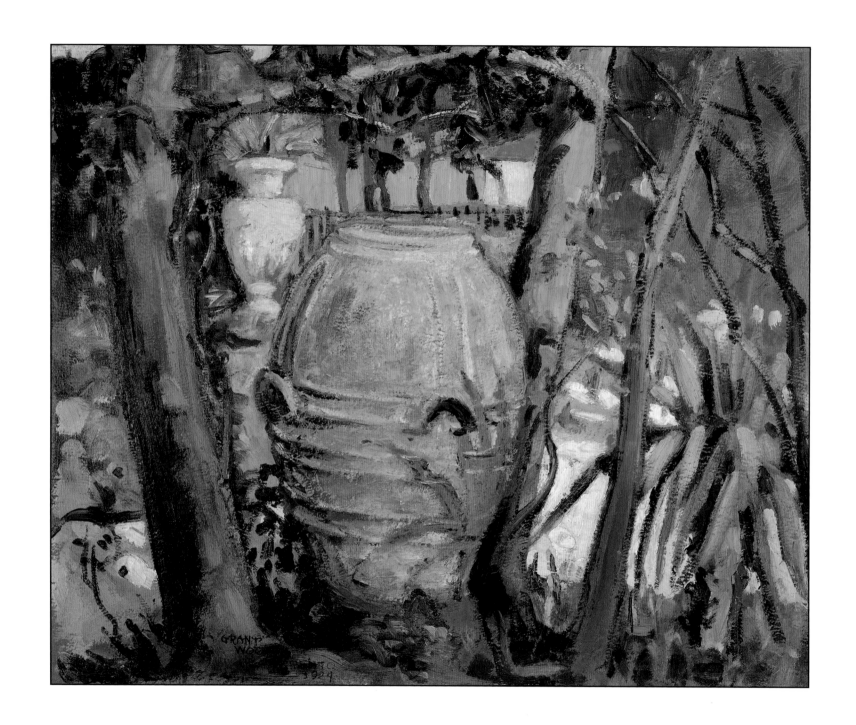

Plate 7
Oil Jar—Sorrento, 1924
Oil on composition board, 12 x 15 in.
Collection of Dr. and Mrs. R. W. Lengeling

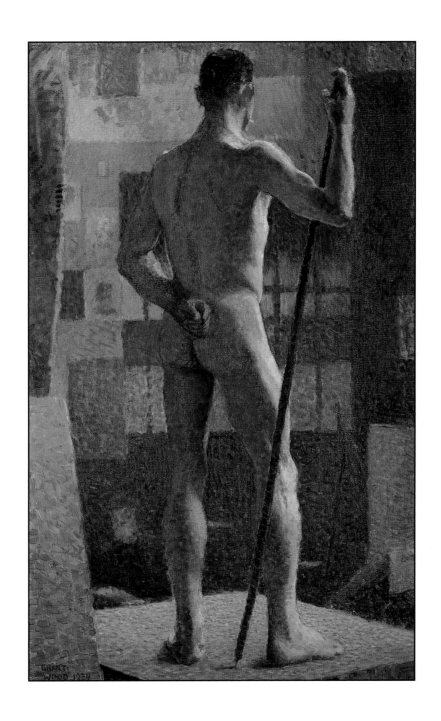

Plate 8
The Spotted Man, 1924
Oil on canvas, 32 x 20 in.
Davenport Museum of Art
Fiftieth Anniversary Purchase, 75.14

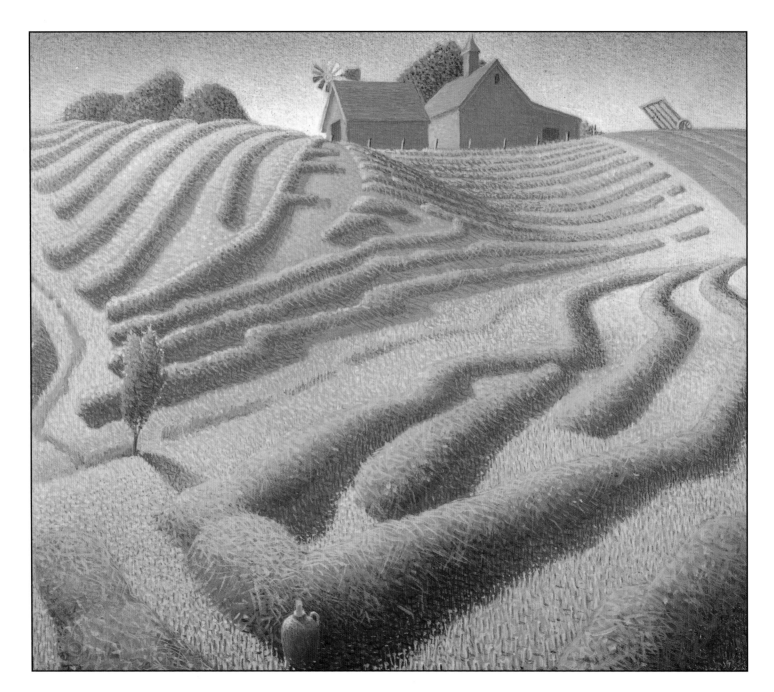

Plate 9
Haying, 1939
Oil on canvas adhered to paperboard mounted on hardboard, 12⅞ x 14⅞ in.
National Gallery of Art, Washington
Gift of Mr. and Mrs. Irwin Strasburger, 1982.7.1
Photograph © 1995 Board of Trustees, National Gallery of Art, Washington

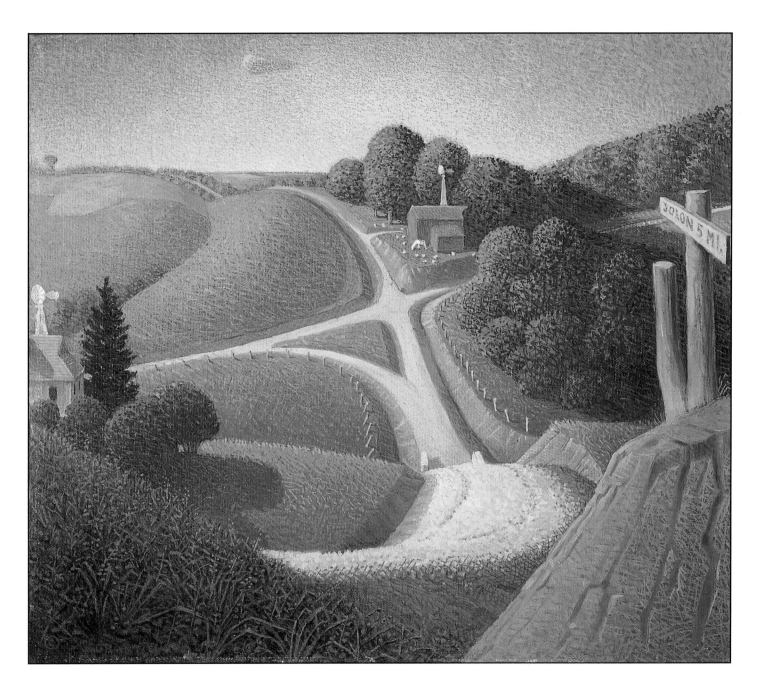

Plate 10
New Road, 1939
Oil on canvas adhered to paperboard mounted on hardboard, 13 x 14⅞ in.
National Gallery of Art, Washington
Gift of Mr. and Mrs. Irwin Strasburger, 1982.7.2
Photograph © 1995 Board of Trustees, National Gallery of Art, Washington

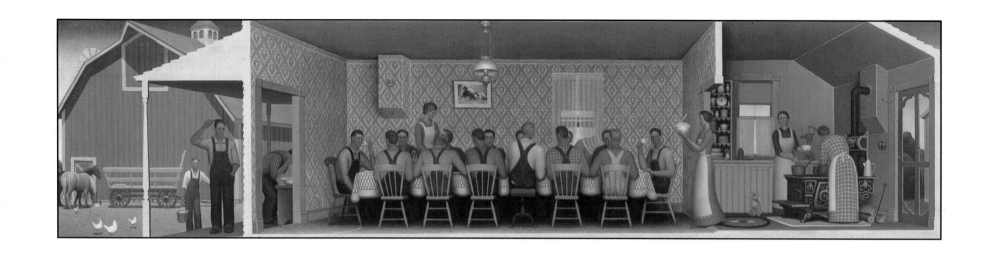

Plate 11
Dinner for Threshers, 1934
Oil on hardboard, 20 x 80 in.
The Fine Arts Museums of San Francisco
Gift of Mr. and Mrs. John D. Rockefeller 3rd, 1979.7.105

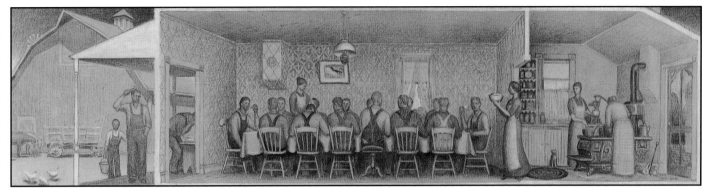

understood by his friends and fellow artists. Upon viewing *La Grande Jatte*, Degas remarked, "You have been in Florence, you have. You have seen the Giottos."[19] Seurat's friend and champion, the critic Félix Fénéon, declared that the work was "as though by a modernizing Puvis."[20]

3 Study for *Dinner for Threshers*, 1934
 Pencil on paper, 18 x 72 in.
 Private collection
 Photograph by Allan Mitchell/Craig Allen Photographs

Grant Wood's stylistic affinities to Seurat's divisionist painting technique and classical compositions are more than coincidental. Wood certainly had numerous opportunities to see the works of the French painter during his lengthy sojourns in Paris and while studying at the Académie Julian. Moreover, Wood was a student at the School of The Art Institute of Chicago in 1913, when the Armory Show, which included works by Seurat, traveled there. *La Grande Jatte* was purchased by Mrs. Frederic Clay Bartlett of Chicago in 1924, exhibited at the Minneapolis Institute of Arts from April through September of 1925, and acquired by The Art Institute of Chicago in 1926.[21] Wood, as an inveterate traveler with connections to the Art Institute—which bought *American Gothic* in

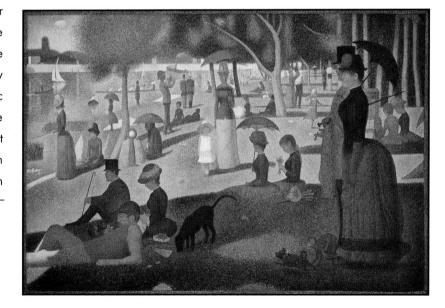

4 Georges Seurat (French, 1859–1891)
 Un dimanche à la Grande Jatte
 (A Sunday afternoon on the island of La Grande Jatte), 1884–1886
 Oil on canvas, 81 ½ x 121 ¼ in.
 The Art Institute of Chicago
 Helen Birch Bartlett Memorial Collection
 1926.224

1930—is likely to have seen the work there, particularly given his early predilection for French painting. In 1931, Wood stated, "When through overwork, I find myself going stale, it is only six hours to Chicago with its stimulating exhibits. I have often gone, planning to spend a week, and found myself home at the end of three days—eager to paint again."[22]

Wood's Seurat-like classicism and divisionist technique are also evident in a more characteristically whimsical and satirical figurative work, *Parson Weems' Fable* (1939, Figure 7, Plate 12). In his humorous treatment of the apocryphal tale of George Washington and the cherry tree popularized by the eighteenth-century clergyman Mason Locke Weems, Wood represents Parson Weems pulling back a curtain to reveal the young Washington. The founding father, replete with Gilbert Stuart head, confesses his naughtiness to his father, a testament to his innate integrity.[23] As in *Dinner for Threshers*, the figures in *Parson Weems' Fable* are geometrically reduced to sculptural forms, particularly Washington's father, whose facial features are nearly eliminated. Yet the

5 Georges Seurat (French, 1859–1891)
 La Pêcheuse à la ligne (A woman fishing), 1884
 Conté crayon on paper, 12⅛ x 9⅜ in.
 The Metropolitan Museum of Art
 Purchase, Joseph Pulitzer Bequest, 1951. Acquired from
 The Museum of Modern Art, Lillie P. Bliss Collection, 55.21.4

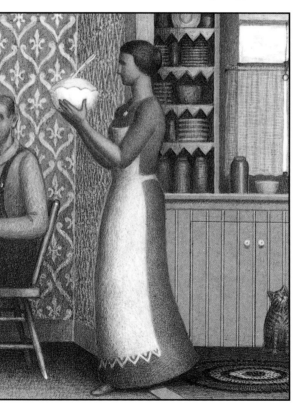

6 Study for *Dinner for Threshers* (detail), 1933
 Graphite and gouache on paper,
 17¾ x 26¾ in. (right section)
 Whitney Museum of American Art,
 New York, 33.80
 Photograph © 1995 Whitney Museum
 of American Art
 (Not in exhibition)

august monumentality apparent in *Dinner for Threshers* is used here to heighten the satire of the myth surrounding the nation's founding father.

This classical stylization is applied to all of the forms in the painting: the trunk of the tree becomes a gracefully arcing cylinder culminating in a perfectly round top adorned with round cherries, which are comically repeated in the fringe of the curtain; trees in the background are reduced to spherical shapes recalling vegetation in *Stone City, Iowa,* from 1930. Shadows on the lawn are reduced to clear, geometric shapes, and blades of grass are compulsively ordered with small strokes of varying shades of green. In the lower left lawn area, a fine cross-hatching of black and mustard yellow against a darker green background sets off the circular red cherries on the round tree. This divisionist technique creates a surface vibrancy enhancing the fantasy-like quality of the scene.

Wood's Seurat-like classicism in *Parson Weem's Fable* and *Dinner for Threshers* also parallels the work of Elie Nadelman, one of the most important and original sculptors practicing in America in the early twentieth century. Nadelman echoed Seurat's silhouetted figures from *La Grand Jatte* in his witty, geometrically stylized bourgeois figures.[24] It is important to note that although Seurat is thought of primarily as a colorist, his draftsmanship, structured compositions, and integration of austere figures in space were also highly infuential. These elements led Stuart Davis to claim that Seurat was his favorite artist[25] and clearly inspired Nadelman and Wood to create archetypal images of the modern world. This Seurat-inspired classicism can also be seen as part of the greater international return to order following the start of World War I.

In reaction to the Cubist abstraction that was prevalent among prewar painters, artists of the 1920s from De Stijl, the Bauhaus, and Purism formed aesthetic programs based on a new classical order. Their utopian beliefs in the restorative power of the industrial era entailed a new role for the artist as designer, rebuilding a war-torn society. As early as the fall of 1916, a shift from Cubist fragmentation of form was declared in the Parisian journal *Sic:* "A work of art must be composed like a precision machine." In November of the same year, the journal reported: "The artist is going to construct a work as an architect makes a house with stone, metal, wood."[26]

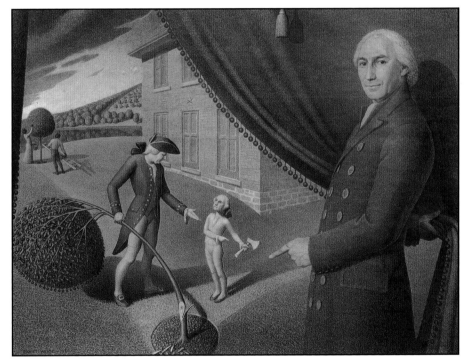

7 Study for *Parson Weems' Fable*, 1939
Charcoal, pencil, and chalk on paper, 38¼ x 50 in.
Private collection

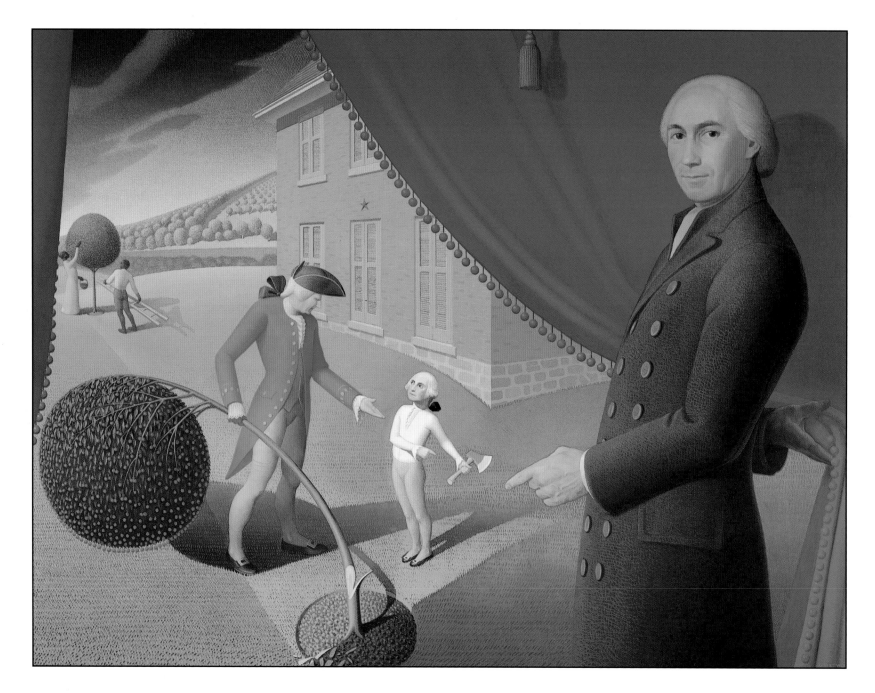

Plate 12
Parson Weems' Fable, 1939
Oil on canvas, 38⅜ x 50⅛ in.
Amon Carter Museum, Fort Worth, Texas
1970.43
(Not in exhibition)

This *rappel à l'ordre,* or "return to order," affected the most significant painters of Paris, including Picasso, Braque, and Léger, who returned to classical figuration.[27] The Purist dictum of Le Corbusier and Amédée Ozenfant, "Man is a geometric animal, animated by a geometric spirit," influenced the cylindrical forms in the figurative paintings of Léger.[28] His *Le Grand Déjeuner* of 1921 (Figure 8) is an aloof *grande machine* of postwar stability in which figures fuse harmoniously with a machine-made environment. The classical composition, emphasizing horizontal and vertical lines and the geometric reduction of archetypal figures, recalls Seurat's great frieze-like composition and anticipates Grant Wood's *Dinner for Threshers.* Indeed, Wood's calculated compositions beginning in the late 1920s seem to be inspired by the same principle articulated by Braque in 1917: "Nobility comes from contained emotion. I love the rule which corrects emotion."[29] In contrast to Wood's early, intuitive Impressionist pictures, his mature paintings, such as *Dinner for Threshers* and the sensuously anthropomorphic *Spring Turning,* are controlled with a reductive purity prevalent among the post–World War I avant-garde.

Die Neue Sachlichkeit and Grant Wood's 1928 Munich Trip: A Stylistic Synthesis

In 1927, Grant Wood received a prestigious local commission from the city of Cedar Rapids to design a stained glass window for the Veterans Memorial Building. During production, the artist was dissatisfied with the quality of windows being fabricated in the United States, leading him to Munich, where the guild tradition of medieval craftsmanship continued at the Emil Frei Company.[30]

While in Munich, Wood admired Northern Gothic painting at the Alte Pinakothek, particularly works by Hans Memling, whom he would acknowledge as an important influence on his mature style.[31] Fifteenth-century Northern Gothic painting had enjoyed a resurgence of popularity in Germany during the 1920s as part of a broader return to realism or objectivity, referred to as "die Neue Sachlichkeit." Like the *rappel à l'ordre* in Paris,

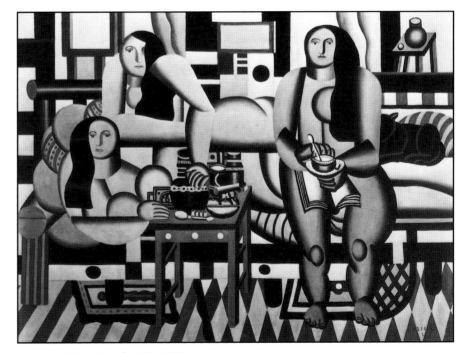

8 Fernand Léger (French, 1881–1955)
Le Grand Déjeuner (Three women), 1921
Oil on canvas, 72 ¼ x 99 in.
The Museum of Modern Art, New York
Mrs. Simon Guggenheim Fund
Photograph © 1995 The Museum of Modern Art, New York

the Neue Sachlichkeit was a return to stability, realism, and, to a certain extent, classical order following the chaos and destruction of World War I. The movement was also a reaction against German Expressionism, prevalent during the first two decades of the twentieth century. Many artists of the 1920s eschewed the Expressionists' romantic explorations of exotic cultures and the inner psyche conveyed with a high degree of figural and spatial distortion.

Neue Sachlichkeit painters such as Otto Dix, Christian Schad, Georg Schrimpf, and Erich Wegner instead concentrated on realistic representations of their modern surroundings. Given the economic and political difficulties in Germany following the harsh conditions imposed by the Treaty of

Versailles, the "objective" artists of Germany in the 1920s, particularly in the north, tended to convey a cynical point of view not characteristic of their Parisian contemporaries. Moreover, unlike the French artists who invoked a classical lineage, from Poussin to Ingres to Seurat, culminating with Picasso's monumental figurative paintings of the 1920s,[32] German artists looked to such Northern Renaissance masters as van Eyck, Memling, Dürer, and Holbein. In addition to his admiration for, and appropriation of, Seurat, Grant Wood admired the same painters as did his German contemporaries of the 1920s.

In Germany, by 1925, when the critic Franz Roh published his seminal *Nach Expressionismus* and G. F. Hartlaub organized the exhibition *Neue Sachlichkeit* in Mannheim, the stylistic commonalities of contemporary German artists seemed to indicate a more or less consistent direction or movement. Roh's summation of these stylistic tendencies bears remarkable affinities to the paintings of Grant Wood following his trip to Munich:

- a return to one-point perspective, three-dimensional form, and realistic proportions
- the simplification of large, volumetric forms and schematic representation without the elimination of minute details which are chosen selectively
- an aloof point of view
- a hard-edged, sharp delineation and modulation of forms [as in Northern Gothic painting]
- use of local color
- stark delineation of color[33]

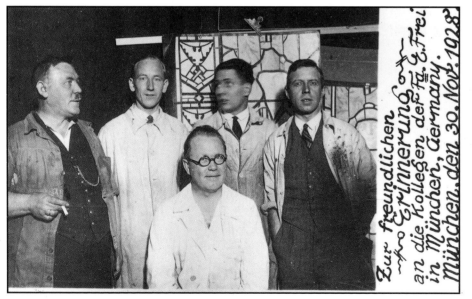

9 Grant Wood and colleagues at the Emil Frei Company, Munich, 1928

Upon returning from Munich, Wood drastically altered his method and style of painting, working in a much more methodical and premeditated fashion than he had in his earlier Impressionist phase. His portraits and landscapes of the late 1920s and early 1930s demonstrate numerous similarities to contemporary German art as described by Roh. For instance, one of Wood's finest fantasy landscape paintings, *Stone City, Iowa*, was created during this period.

Stone City is best known as the site of Wood's short-lived art colony, where he headed a small group of teachers and students for two summers in 1932 and 1933. But before that, the town's rural setting and dramatic escarpment served as the starting point for a pivotal painting. The basic design of the complex composition is worked out in a Cézannesque plein air sketch (Figure 10) recalling Wood's work from the early 1920s. Yet in the late 1920s, and for the remainder of Wood's career, these loosely painted panels would serve as the starting point for a number of his finely finished compositions.

The final version of *Stone City, Iowa* (Plate 13) demonstrates Wood's departure from his earlier

10 Study for *Stone City*, 1930
 Oil on Masonite panel, 13 x 15 in.
 Davenport Museum of Art, 65.4

style in works such as *The Grand Cascade Bois de Bologne, Paris* (Plate 6). The impasto application, exaggerated colors, and relative flatness of the earlier painting give way to clearly delineated forms rendered with local color in a recessional space. These characteristics and the overall schematic stylization recall Neue Sachlichkeit paintings such as *Winterlandschaft* (1928) by Erich Wegner (Figure 11). Indeed, in March 1931 the Frankfurt

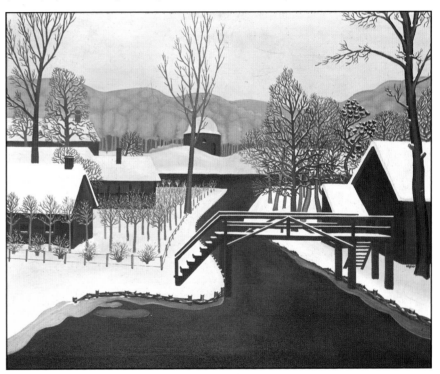

11 Erich Wegner (German, 1899–1980)
 Winterlandschaft (Winter landscape), 1928
 Oil on canvas, 28 x 34¼ in.
 Sprengel Museum, Hannover, Germany

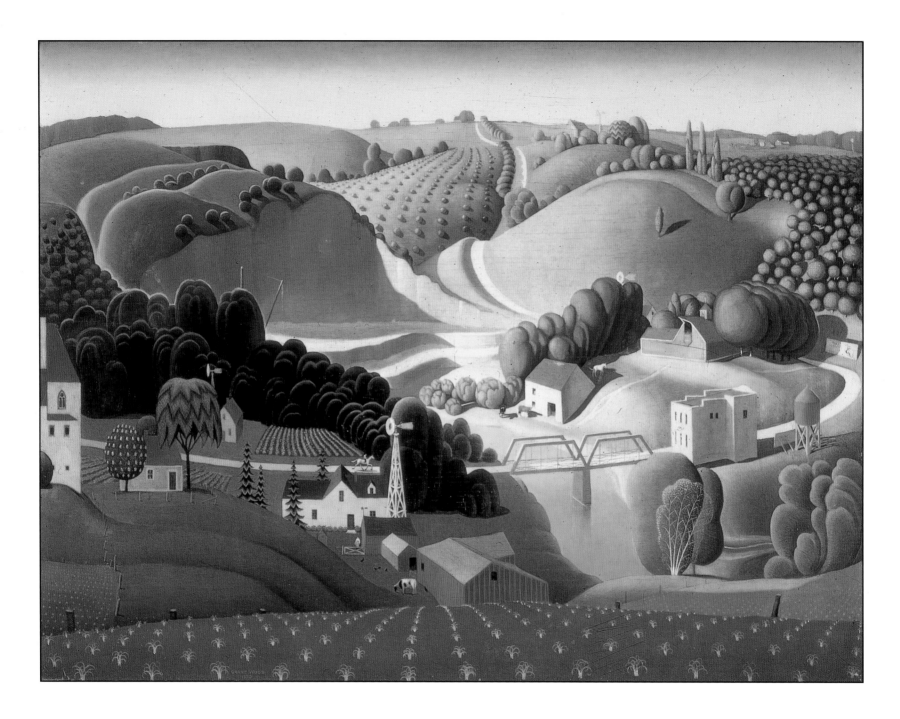

Plate 13
Stone City, Iowa, 1930
Oil on wood panel, 30¼ x 40 in.
Joslyn Art Museum, Omaha, Nebraska
Art Institute of Omaha Collection, 1930.35

newspaper *Das Illustrierte Blatt* featured a large reproduction of *Stone City, Iowa* with the caption "Neue Sachlichkeit in Amerika" (Figure 12), in recognition of the stylistic affinities.[34]

Wood's response to German painting following his 1928 trip is not unlike that of another American painter from the period, Charles Sheeler. In 1929, Sheeler traveled to Munich, where he, like Wood, admired the clarity and exactitude of Northern Gothic paintings by van Eyck, Memling, and Holbein.[35] With his emphasis on Cubist-inspired planar reduction of Shaker objects, architecture, and industrial landscapes, Sheeler had already demonstrated an awareness of and participation in the international classicizing between the wars. However, after his return from Munich, Sheeler painted *Classic Landscape,* one of his greatest Precisionist works. It bears numerous stylistic similarities to Grant Wood's post-Munich paintings, indicating that both artists had more than a coincidental connection with Neue Sachlichkeit painting.

Classic Landscape has its genesis in documentary photographs that Sheeler was commissioned by the Ford Motor Company to produce in 1927. The preliminary watercolor, painted in 1928, was followed by the final version in oil from 1931 (Figure 13). In the angular composition of the foreground, clearly delineated slag heaps follow the clean lines of railroad tracks that lead back to a pure, planar white building with a columnar smokestack. In contrast to the rushing perspective of the rail line, the horizontal and vertical lines of the building sit statically, like a modern temple of the industrial age. Although the subject of

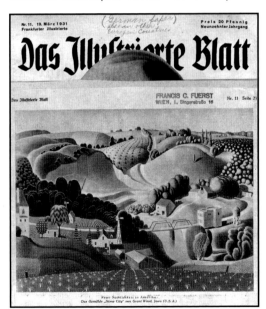

12 Page from the Frankfurt, Germany, newspaper *Das Illustrierte Blatt*, March 19, 1931, referring to stylistic similarities of Wood's *Stone City, Iowa* and Neue Sachlichkeit paintings.

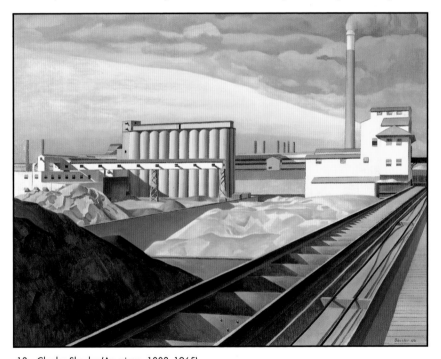

13 Charles Sheeler (American, 1883–1965)
Classic Landscape, 1931
Oil on canvas, 25 x 32¼ in.
Collection of Mr. and Mrs. Barney A. Ebsworth Foundation

Sheeler's painting is industry, the schematic reduction of volumetric forms and clear delineation of objects with local colors has a marked stylistic affinity to Wood's *Stone City, Iowa* of one year earlier and to German painting of the 1920s. It seems that both Wood and Sheeler absorbed stylistic tendencies from a number of sources, including early Renaissance art, Northern Gothic painting, and the Neue Sachlichkeit. These sources aided in generating highly original and complex styles of realism in American painting of the 1930s.

Die Neue Sachlichkeit and Grant Wood's Post-Munich Portraiture

Prior to Wood's trip to Munich, portrait painting played a relatively inconsequential role in his work.[36] However, upon the artist's return to America, portraiture became a recurring theme in his meticulous, mature style. Wood's portraits from the 1930s reflect a degree of social criticism and satire that is, though less cynical, in keeping with the figurative painting of the Neue Sachlichkeit movement.

In two of his well-known figurative works from the 1930s, Wood turned a satirical eye to city folk in true Regionalist fashion. In *Appraisal* (1931, Plate 14), the title's double entendre refers not only to the affluent and out-of-place city dweller's estimation of the fowl but also to the seemingly simple country woman's sly appraisal of her well-preened urban counterpart, whose profile bears an uncomfortable resemblance to the hen's.

A year later, Wood turned his critical attention to the Daughters of the American Revolution, a group that had prevented the dedication of the Cedar Rapids stained glass window on the grounds that the war memorial had been fabricated with the assistance of Germans, America's enemy in World War I. Wood's caricature of the central figure in *Daughters of Revolution* (Figure 14, Plate 15), a humorless, thin-lipped lady with a claw-like hand, recalls to a certain extent the grotesque exaggeration employed by some Neue Sachlichkeit painters. On the wall in the background is a representation of *Washington Crossing the Delaware,* a painting the national DAR had worked to have restored and displayed at the Metropolitan Museum of Art. Ironically, the painting was created by German-born Emanuel Leutze in Düsseldorf, Germany.[37]

Wood's most brilliant satirical work, painted shortly after his return from Munich, offers a composite of the people he knew best and with whom he maintained an affectionate yet ambivalent relationship—rural midwesterners. Wood used his sister, Nan, and a Cedar Rapids dentist, B. H. McKeeby, as the models for *American Gothic* (Plate 16), the 1930 painting that captured the somber mood of the Depression era and propelled the artist into international fame. In this iconic portrayal of a simple, hardworking farmer and his wife,[38] Wood created a subtle balance between homage and satire. The armed farmer's defensive stance, which borders on aggression, indicates a narrow-mindedness that is accentuated by his elongated "gothic" features, literally suggesting a narrow, simple, and direct point of view. Wood's balance between objectivity and satire recalls an earlier portrait by Otto Dix.

Dix's *Die Eltern des Künstlers II* (1924, Figure 15) portrays the artist's simple, hardworking parents. His father's great hands express a lifetime of toil as a manual laborer.[39] But his narrow, somewhat vacuous gaze and comical mustache, which nearly subsumes the lower portion of his

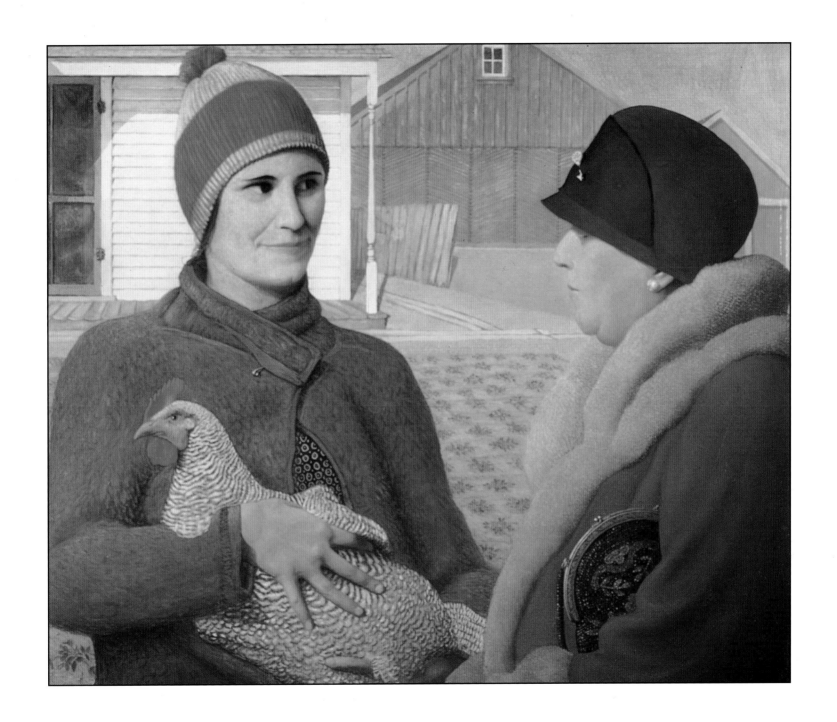

Plate 14
Appraisal, 1931
Oil on composition board, 29 ½ x 35 ¼ in.
Carnegie-Stout Public Library, Dubuque, Iowa

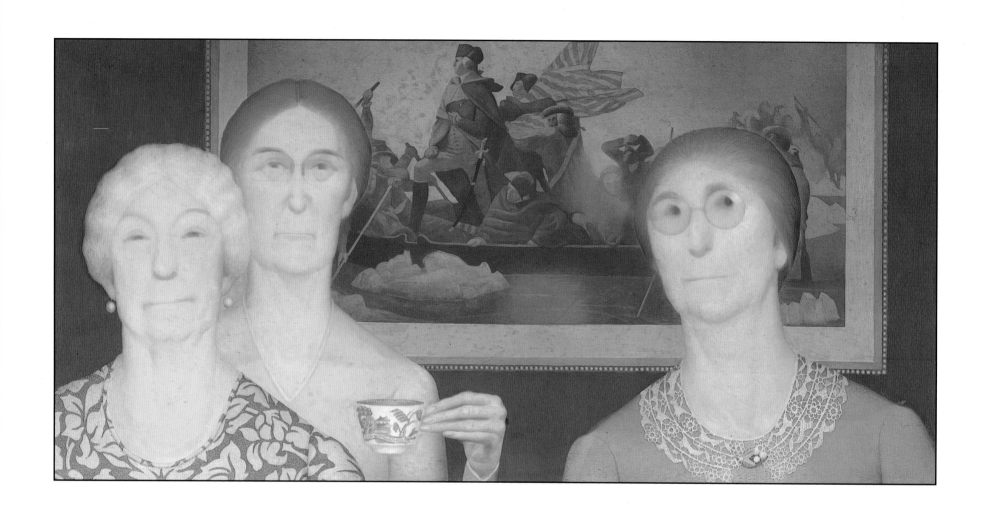

Plate 15
Daughters of Revolution, 1932
Oil on Masonite panel, 20 x 40 in.
Cincinnati Art Museum
The Edwin and Virginia Irwin Memorial, 1959.46

face, suggest a dual purpose to Dix's portrait: it is both a straight-forward, earnest representation of his parents and a gentle satire of their simple nature, done with affection. Despite similarities in composition and content, it is unlikely that Wood used this painting as a model for *American Gothic*. However, both artists were keen observers of human nature and individual foibles, suggesting an affinity of outlook that also extended to style.

A Partial Return from Bohemia

In 1935, Grant Wood arranged with Doubleday to publish an autobiog-raphy entitled *Return from Bohemia* (the book was never completed). The title alludes to Wood's return from Europe and his ostensible stylistic return to an anti-modern, anti-European realism. The first chapter, recounting the

artist's youth on a farm, was written by Park Rinard, Wood's friend and secretary, who submitted the work as his master's thesis at the State University of Iowa (now the University of Iowa).[40] In the same year, Wood designed the cover illustration for the book (Plate 17), which was reproduced

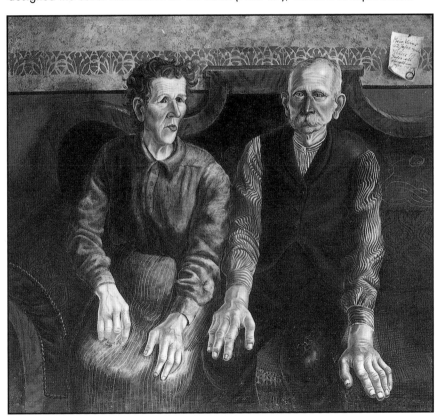

15 Otto Dix (German, 1891–1969)
Die Eltern des Künstlers II (The artist's parents), 1924
Oil on canvas, 46 ½ x 51 ⅜ in.
Sprengel Museum, Hannover, Germany

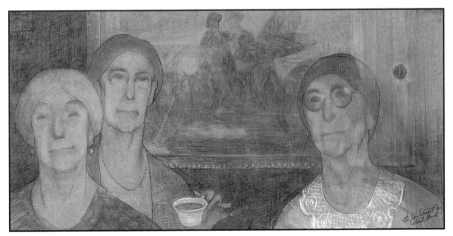

14 Study for *Daughters of Revolution*, 1932
Pencil, charcoal, and chalk on paper, 22 x 41 ¾ in.
Coe College Permanent Collection of Art, Cedar Rapids, Iowa

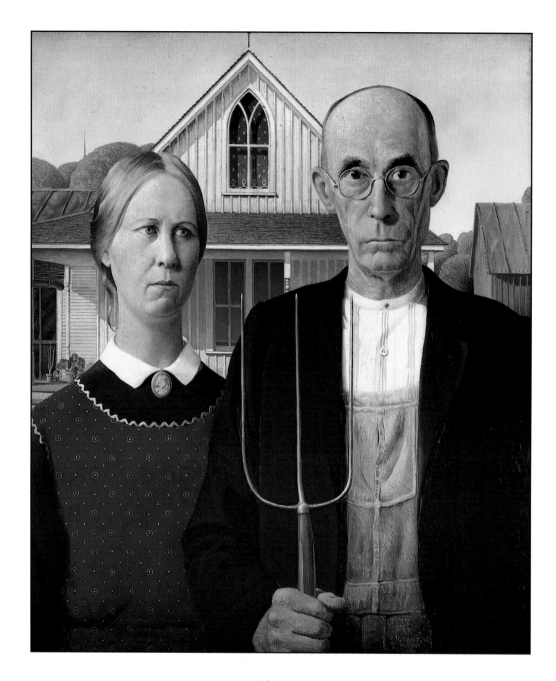

Plate 16
American Gothic, 1930
Oil on beaver board, 29⅞ x 24⅞ in.
The Art Institute of Chicago
Friends of American Art Collection, 1930.934
Photograph © 1994 The Art Institute of Chicago

Plate 17
Return from Bohemia, 1935
Crayon, gouache, and pencil on paper, 23 ½ x 20 in.
The Regis Collection, Minneapolis, Minnesota

Plate 18
Booster, 1936
Charcoal, pencil, and chalk on brown paper, 20½ x 16 in.
Davenport Museum of Art
Friends of Art Permanent Endowment Fund and a gift from Mr. and Mrs. Morris Geifman, 93.3

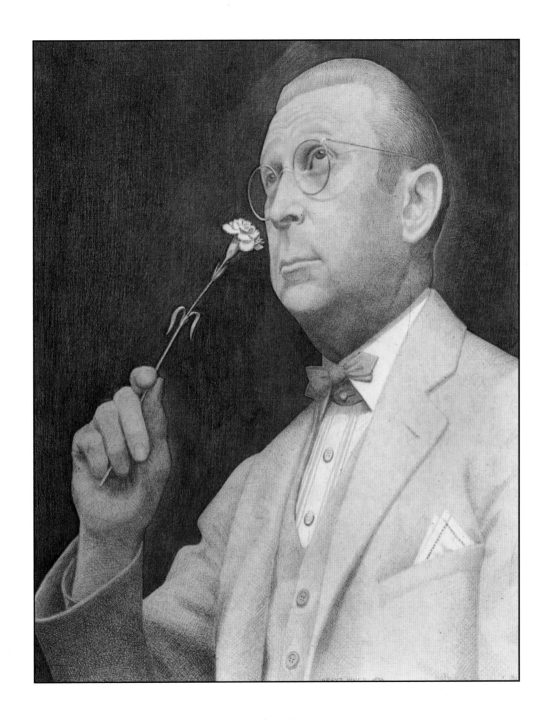

Plate 19
Sentimental Yearner, 1936
Crayon, gouache, and pencil on paper, 20¼ x 16 in.
The Minneapolis Institute of Arts
Gift of Alan Goldstein, 80.91

in a Sunday edition of the *New York Herald Tribune* with a nationally syndicated story in which the artist recounted his proverbial return:

> I lived in Paris a couple of years myself and grew a very spectacular
> beard that didn't match my face or my hair, and read Mencken and
> was convinced that the Middle West was inhibited and barren. . . .
> I joined a school of painters in Paris after the war who called

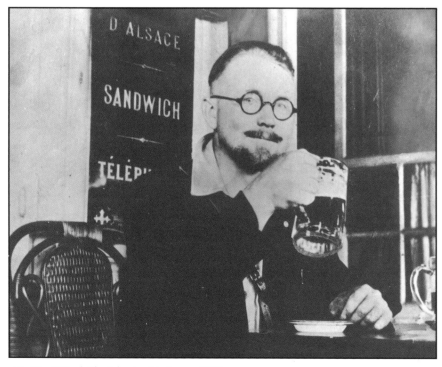

16 Grant Wood, "the Bohemian," in Europe, 1920

themselves neo-meditationists. They believed an artist had to wait for inspiration very quietly, and they did most of their waiting at the Cafe du Dome or the Rotunde, with brandy. It was then that I realized that all the really good ideas I'd ever had came to me while I was milking a cow. So I went back to Iowa.[41]

Wood's folksy glorification of his return to America following what he described as a decadent and shallow visit to Europe reflects a broader cultural shift from the Roaring Twenties to the isolationist 1930s in America. From the literature of Steinbeck and Faulkner to the American Scene painters, artists in the United States turned inward, eschewing the international tendencies of expatriate artists of the 1910s and 1920s such as Fitzgerald, Hemingway, Stein, and Gerald Murphy.

Wood's rhetorical dismissal of mainstream modernism reached a crescendo with the publication of his 1935 Regionalist manifesto, "Revolt Against the City." In this vehemently anti-Parisian and anti–East Coast diatribe, Wood declared that "Paris is no longer the Mecca of the American artist. The American public . . . has readily acquired a strong interest in the distinctly indigenous art of its own land."[42] In promoting his regional, nonurban art movement, Wood further proclaimed that "New York galleries played into the hands of the French promoters because they themselves found such a connection profitable."[43]

The rhetoric of "Revolt" ranges in its broad articulation of issues from economics and politics to history as they related to the current cultural scene. The essay was written with the assistance of Frank Luther Mott, a colleague of Wood at the State University of Iowa who taught in the journalism

Plate 20
The Perfectionist, 1936
Crayon, gouache, charcoal, ink, and opaque watercolor on brown wove paper, 25⅝ x 20 in.
The Fine Arts Museums of San Francisco
Gift of Mr. and Mrs. John D. Rockefeller 3rd, 1979.7.106

department and who published the work.[44] It seems likely that Mott wrote more of "Revolt" than did Wood, just as Park Rinard authored Wood's incomplete autobiography of the same year.[45]

Wood's subsequent remarks demonstrate a more ambiguous regard for French painting than was expressed in "Revolt." A newspaper article about Wood published in 1936 reported that "the idea he is opposed to the French thought is wrong," going on to quote the artist: "'I really like the French viewpoint and I am trying hard to fight down this fable.'"[46] Earlier, in a 1932 interview, Wood had remarked, "Modernism has added a new force, a new drive and a lot of valuable tools to the kit of the artist."[47] In another interview from the same year, he had stated, "I retained what I thought was lasting in the Modernistic movement"—hardly the wholesale rejection of modernism presented in "Revolt."[48]

By 1937, Wood felt compelled to draft a more moderate version of his viewpoints for a graduate seminar at the University of Iowa. In this concise, one-page definition of the artistic movement for which he had become the national spokesman, Wood wrote, "Regionalism, as I have used the term, pertains to artistic methods; it is an elaboration of the general proposition that art, although potentially universal in significance, is always more or less local in inception."[49] Wood saw Regionalism as a national school in which artists from different regions of the country could express what they knew best: their local surroundings.[50] Although Wood claimed to be opposed to copying the subject matter or style of other artists, this did not preclude him from enriching his mature paintings with elements of modern European art. Indeed, in the pamphlet for the Stone City Colony and Art School in 1932, Wood conveyed an approach to art condoning such eclecticism: "Our theory being that when a painter has a definite message, he will, by experiment, find the most adequate means of expressing it, let the result be as conservative, as eclectic or as radical as it may."[51] Thus, Wood's "return from Bohemia" can be seen as less of a clear break from Europe than is invoked by the title of the painting. The artist's complex relationship with European art is apparent in his major self-portraits from the 1930s.

In the two drawings for *Return from Bohemia* (Plates 17 and 21), Wood depicts himself working *en plein air* as he did in the French countryside, yet he is surrounded by local Iowans and placed against the architectural foil of a barn rather than a chapel. As the focus of a hierarchical arrangement of spectators bowing their heads reverently, the artist gazes intensely at the viewer in celebration of his creative powers. The geometrically arranged figures are given formal import by their columnar rigidity and reductive, sculptural features, recalling Seurat's classicism. In the initial drawing (Plate 21), the allover crosshatching of colored strokes creates a surface vibrancy reminiscent of Neo-Impressionism. In typical fashion, the final version of the drawing is more linear and streamlined.

These drawings also incorporate elements of modern German art, specifically recalling the intense sobriety of the numerous self-portraits by such Neue Sachlichkeit painters as Max Beckmann and Otto Dix. In *Return from Bohemia,* Wood portrays himself as an intense but stoic recorder of the world around him, much as Otto Dix did in his 1926 self-portrait (Figure 17). The composition of Dix's painting, particularly the positioning of the hand, refers to Dürer's famous oil-on-panel self-portrait

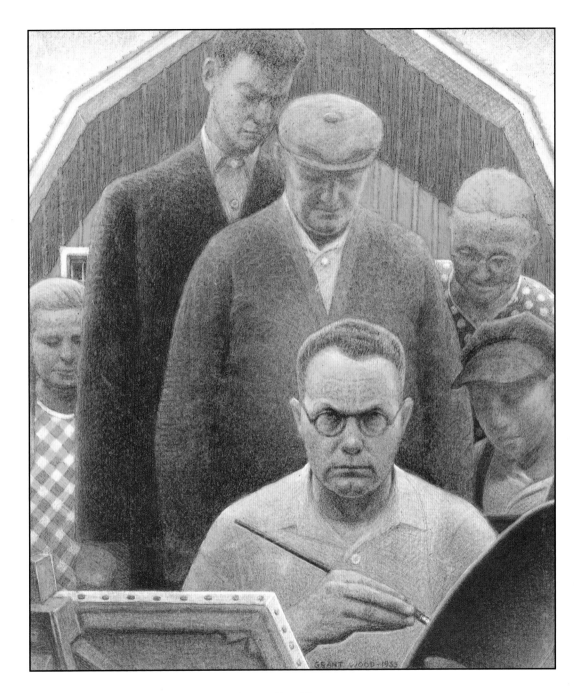

Plate 21
Return from Bohemia, 1935
Pastel on paper, 23¾ x 20 in.
Collection of IBM Corporation, Armonk, New York
Photograph courtesy Sotheby's, New York
(Not in exhibition)

of 1500 in the Alte Pinakothek,[52] a painting with which Grant Wood was no doubt familiar[53] and that he may have had in mind when working on *Return from Bohemia*.

Dix's self-portrait, *Selbstbildnis mit Staffelei*, part of a series of compositions inspired by Dürer and Lucas Cranach,[54] employed a glazing of thin, translucent layers of paint on a smooth, flat panel to achieve an Old Master–like finish that was also in keeping with the machine age aesthetic of the Neue Sachlichkeit. In a broader sense, Dix's renewed interest in the Northern Renaissance related to the "return to order" of the late 1910s and 1920s and the impulse to create an artwork with the lasting solidity of an Old Master painting.

After his return from Munich, Wood also began painting in oil glazes on panel in compositions alluding to Old Master works. His 1932 *Self Portrait* (Figure 18, Plate 22) combines the format of Northern Gothic portraiture with the added surface vibrancy of pointillism. The skin tones are built up with a complex web of blue, green, red, and peach paint that blends together when viewed from a distance (Figure 19). Wood's fine pointillism is tempered with the linear clarity of Northern Gothic and modern German painting. Moreover, the artist's stoic countenance recalls Northern Renaissance portraits but with the added psychological intensity of the Neue Sachlichkeit. Wood's mysterious record of himself, which he kept in his studio until his death, suggests a more complex individual than the simple "farmer in overalls" persona he presented publicly.[55]

The varied stylistic sources seen in Wood's self-portraits dating back to his travels in Europe are also evident in paintings such as

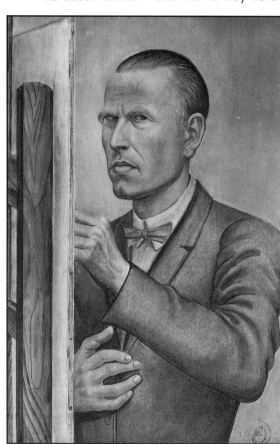

17 Otto Dix (German, 1891–1969)
Selbstbildnis mit Staffelei
(Self-portrait with easel), 1926
Oil on panel, 31 ¾ x 21 ⅞ in.
Leopold-Hoesch-Museum, Düren, Germany

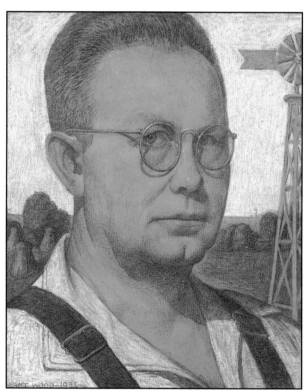

18 Study for *Self Portrait*, 1932
Charcoal and pastel on paper, 14 ½ x 12 in.
Cedar Rapids Museum of Art, Cedar Rapids, Iowa
Art Association Purchase, 93.11

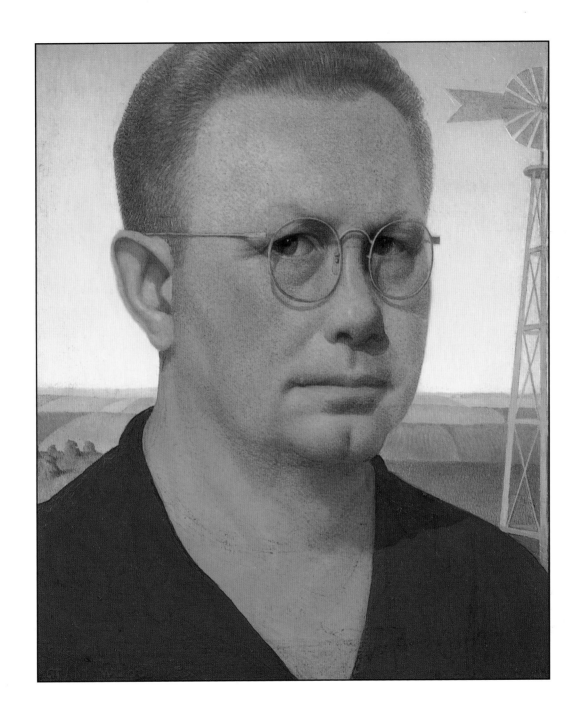

Plate 22
Self Portrait, 1932
Oil on Masonite panel, 14¾ x 12⅜ in.
Davenport Museum of Art, 65.1

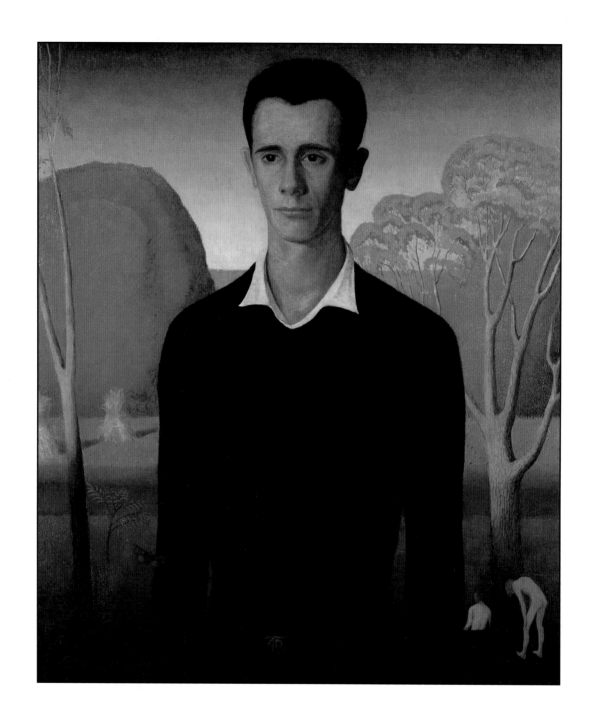

Plate 23
Arnold Comes of Age, 1930
Oil on board, 26¾ x 23 in.
Sheldon Memorial Art Gallery, University of Nebraska–Lincoln
Nebraska Art Association Collection, 1931.N-38

Arnold Comes of Age (1930, Plate 23). In this painting of his friend and studio assistant Arnold Pyle on the occasion of his twenty-first birthday, Wood combined styles of French and German painting he had observed in the 1920s. Allegorical elements allude to Arnold's maturation: slender, columnar trees; a butterfly, symbolic of the transformation into adulthood; adolescent bathers presented in a Puvis-like manner, indicating youth. The clarity of the reductive forms, stark delineation of colors, selective use of details, and rigid

pose of the sitter recall stylistic traits of Neue Sachlichkeit painting and Gothic portraiture.

Arnold Comes of Age is a representative example of the stylistic synthesis Grant Wood developed after his fourth trip to Europe, in 1928. His unique combination of Northern Gothic painting, early Italian Renaissance art, Neo-Impressionism as practiced by Seurat, and Neue Sachlichkeit painting is evident in Wood's finest works throughout his career, including *Stone City, Iowa* (1930), *American Gothic* (1930), *Self Portrait* (1932), *Dinner for Threshers* (1934), *Spring Turning* (1936), *Return from Bohemia*

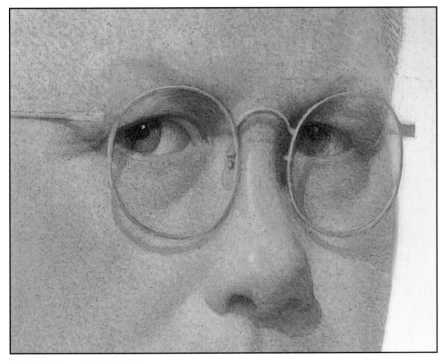

19 *Self Portrait* (detail), 1932
Oil on Masonite panel, 14¾ x 12⅜ in.
Davenport Museum of Art, 65.1

20 John Steuart Curry and Grant Wood in Stone City, Iowa, 1932

(1935), and *Parson Weems' Fable* (1939), placing the artist more clearly in the context of broader developments in modern art than his rhetoric or the history of Regionalism would indicate.

A Note on Source Material

The Davenport Museum of Art houses the Grant Wood Archives, eighteen volumes of published articles pertaining to Wood's life and work as well as correspondence by the artist compiled by his sister, Nan Wood Graham. These archives continue to be an excellent resource for Wood scholarship. Another major source of information about Grant Wood is the Archives of American Art, Smithsonian Institution, Washington, D.C. The two standard monographs on Grant Wood are James M. Dennis, *Grant Wood: A Study in American Art and Culture* (New York: Viking Press, 1975), and Wanda M. Corn, *Grant Wood: The Regionalist Vision* (New Haven, Conn.: Yale University Press, 1983). These remain the starting point for all serious considerations of the artist.

Notes

1. Henry Adams, *Thomas Hart Benton: An American Original* (New York: Alfred A. Knopf, 1989).
2. M. Sue Kendall, *Rethinking Regionalism: John Steuart Curry and the Kansas Mural Controversy* (Washington, D.C.: Smithsonian Institution Press, 1986).
3. Wanda M. Corn, *Grant Wood: The Regionalist Vision* (New Haven, Conn.: Yale University Press, 1983).
4. The influence of Neue Sachlichkeit painting on Wood is introduced by H. W. Janson in "The International Aspects of Regionalism," *College Art Journal* 2 (May 1943): 110–15, and is further discussed in James Dennis's *Grant Wood: A Study in American Art and Culture* (New York: Viking Press, 1975).
5. Grant Wood Archives, Davenport Museum of Art.
6. Corn, *Grant Wood*, 104.
7. William I. Homer, *Seurat and the Science of Painting*, quoted in Bernard Dunstan, *Painting Methods of the Impressionists* (New York: Watson-Guptill, 1983), 101.
8. In a letter to his New York dealers, Wood referred to the paintings *New Road* and *Haying* as sketches. Archives of American Art, Smithsonian Institution, Washington, D.C. (hereinafter cited as AAA), 1939. A note on the back of each painting indicates that the artist reserved the right to make larger paintings of the same subject. National Gallery of Art, artist file. The degree of finish suggests that these paintings were created, at least in part, in the artist's studio.
9. Edward Alden Jewell, "Visions That Stir the Mural Pulse," *New York Times*, May 27, 1934.
10. J. Sanford Rikoon, *Threshing in the Midwest, 1820–1940* (Bloomington and Indianapolis: Indiana University Press, 1980), 121.
11. Corn, *Grant Wood*, 104.
12. Robert Herbert, *Georges Seurat, 1859–1891* (New York: Metropolitan Museum of Art, 1991), 174.
13. Ibid., app. E.
14. Just prior to Seurat's enrollment at the École, Charles Blanc, director of the school, promoted the "Italian Primitives" by arranging for oil copies of Piero's murals to be exhibited. Reproductions were also easily accessible in the École's library. See Albert Boime, "Seurat and Piero della Francesca," *Art Bulletin* 47 (June 1965): 265–71.
15. Ibid., 266–67.
16. John Rewald, *Seurat: A Biography* (New York: Harry N. Abrams, 1990), 97–104.
17. *Time* 2, no. 5 (March 4, 1935).
18. Jewell, "Visions That Stir the Mural Pulse." See also Dennis, *Grant Wood*, 134.
19. Herbert, *Georges Seurat*, 174.
20. Rewald, *Seurat: A Biography*, 104.
21. *Museum Studies* (Art Institute of Chicago) 14, no. 2 (1989): 252.
22. "Grant Wood Explains Why He Prefers to Stay in the Middle West in Talk at Kansas City," *Cedar Rapids Sunday Gazette and Republican*, March 22, 1931. Grant Wood Archives, Davenport Museum of Art.
23. Dennis, *Grant Wood*, 112–14.
24. Lincoln Kirstein, *Elie Nadelman* (New York: Eakins Press, 1973), 168–69.
25. William C. Agee, "Stuart Davis in the 1960s: 'The Amazing Continuity,'" in *Stuart Davis: American Painter*, ed. Lowrey Stokes Sims (New York: Metropolitan Museum of Art, 1991), 93.
26. William C. Agee, "The Recovery of a Forgotten Master," in William C. Agee and Barbara Rose, *Patrick Henry Bruce* (New York: Museum of Modern Art; Houston: Museum of Fine Arts, 1979), 26.
27. This "return to order" was a "resurfacing" of classicizing tendencies in avant-garde circles that had its origins with the Post-Impressionists and was dominant at the beginning of the twentieth century with Picasso and Matisse, especially after 1905, when important retrospective exhibitions of Seurat and Ingres were presented in Paris. See Elizabeth Cowling and Jennifer Mundy, *On Classic Ground: Picasso, Léger, de Chirico, and the New Classicism 1910–1930* (London: The Tate Gallery, 1990), 200.
28. *Léger and Purist Paris* (London: The Tate Gallery, 1970).
29. Ibid., 44.
30. Dennis, *Grant Wood*, 67.
31. Ibid., 68.
32. Robert Rosenblum, *Cubism and Twentieth Century Art* (New York: Harry N. Abrams, 1961), 126.

33. Franz Roh, *Geschichte der Deutschen Kunst von 1900 bis zur Gegenwart* (Munich: Beckmann Verlag, 1958), 113.

34. *Das Illustrierte Blatt* (Frankfurt, Germany) 19, no. 11 (March 19, 1931): 271.

35. Martin Friedman, *Charles Sheeler* (Washington, D.C.: National Collection of Fine Arts, 1968), 18.

36. Wood did create several conservative portraits of Cedar Rapids sitters in the 1920s.

37. Corn, *Grant Wood*, 98–101.

38. Despite frequent accounts to the contrary, Wood intended the couple to represent a husband and wife. In describing the development of *American Gothic*, Wood stated, "I finally induced my own maiden sister to pose and had her comb her hair strait down over her ears, with a severely strait part. The next job was to find a man to represent the husband." "An Iowa Secret," *Art Digest* 8 (October 1933): 6.

39. Brigid S. Barton, *Otto Dix and Die Neue Sachlichkeit 1918–1925* (Ann Arbor: University of Michigan Press, 1981), 58.

40. Corn, *Grant Wood*, 112.

41. *New York Herald Tribune*, January 19, 1936. AAA, roll 1216.

42. Dennis, *Grant Wood*, 229–35.

43. Ibid.

44. Nan Wood Graham referred to an original copy of "Revolt Against the City" with the inscription "I ghost wrote this for Grant" signed by Frank Luther Mott. She also noted that Grant was "easy going, and revolt was not part of his nature." Nan Wood Graham, John Zug, and Julie Jensen McDonald, *My Brother, Grant Wood* (Iowa City: State Historical Society of Iowa, 1993), 124.

45. Corn, *Grant Wood*, 153 n. 85.

46. "Paris Art O.K. in Paris, Says Painter Wood," unidentified newspaper, January 1936. AAA, roll 1216, frame 544.

47. "Many Turn Out for Lecture by Iowa Artist," *Dubuque Telegraph-Herald and Times-Journal*, March 9, 1932.

48. *Christian Science Monitor*, March 26, 1932.

49. Grant Wood, "A Definition of Regionalism," November 17, 1937. Grant Wood Archives, Davenport Museum of Art.

50. As Henry Adams shows us, Regionalism was largely the invention of the dealer Maynard Walker, who linked Benton, Curry, and Wood as a promotional ploy in 1933. It was Walker who wrote of "an American art that springs up from American soil and seeks to interpret American life." The triumvirate of what would be known as Regionalism was featured in *Time* magazine in 1934, giving the three national prominence as a group. As Benton remarked, "A play was written and a stage erected for us. Grant Wood became the typical Iowa small towner, John Curry [who had been living at an art colony in Connecticut] the typical Kansas farmer, and I [Benton had been living in New York City] just an Ozark hillbilly. We accepted our roles." See Adams, *Thomas Hart Benton*, 221.

51. Grant Wood, "The Aim of the Colony," pamphlet for the Stone City Colony and Art School, 1932.

52. Sergiusz Michalski, *New Objectivity* (Cologne: Benedikt Taschen, 1994), 59.

53. In fact, Wood visited Dürer's hometown, Nuremburg, while in Germany. See Dennis, *Grant Wood*, 238–39 n. 7.

54. Michalski, *New Objectivity*, 59.

55. Wood never finished the painting, unable to resolve the formal arrangement of his overall straps (seen in the preparatory drawing for *Self Portrait*, Figure 18) with the competing patterns created by bands of fields in the background. Wood painted over the straps at some point and left the shirt unfinished (see page 83). Late in his career, he signed the painting with the note "sketch."

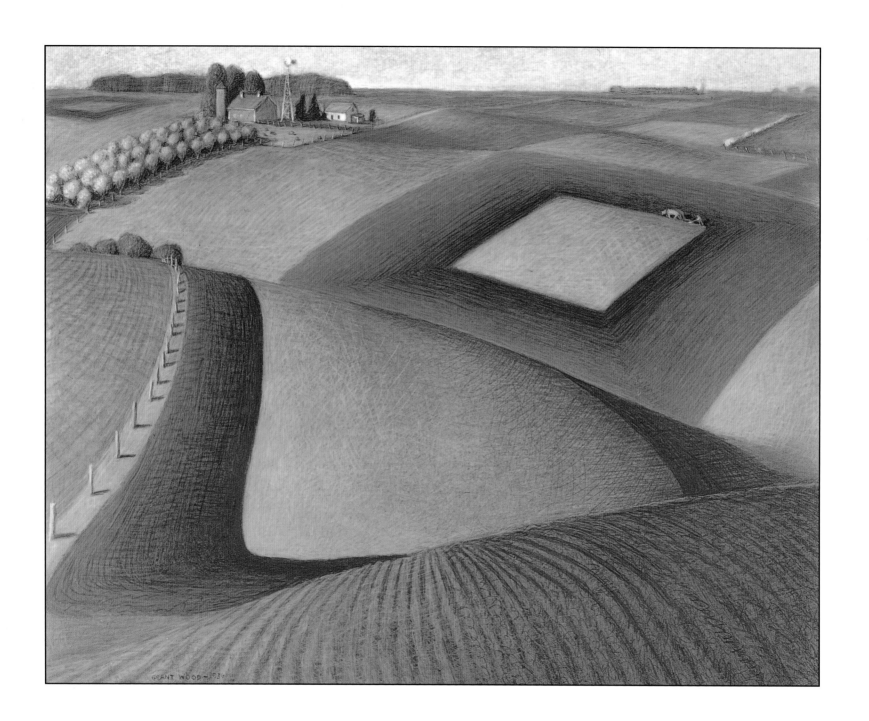

Plate 24
Plowing, 1936
Charcoal, crayon, chalk, and pencil, 23 ½ x 29 ½ in.
Private collection
(Not in exhibition)

GRANT WOOD'S NATIVE-BORN MODERNISM

BY JAMES M. DENNIS

Not a picture of a flower is sought—that can be left to the botanist—but rather an irregular pattern of lines and spaces, something far beyond the mere drawing of a flower from nature.

—Arthur W. Dow, *Composition*

Grant Wood's interest in modern trends of composing a picture originated with the Arts and Crafts movement, in its emphasis on ornamental patterning. He first became familiar with this aspect of design in his late teens through a correspondence course offered by art educator Ernest A. Batchelder in Gustav Stickley's *Craftsman Magazine*. This initial exposure led him to another American source of modernism, Arthur Wesley Dow, whose manual *Composition: A Series of Exercises in Art Structure for the Use of Students and Teachers* was to pace American art education for decades. Although he was not as heavily influenced as were his contemporaries Georgia O'Keeffe and Arthur Dove, Wood shared with them certain Dowian principles of modernism in a number of tree-filled landscapes during the late 1910s. Approximately ten years later, his growing modernist tendencies closely matched the concepts of "pictorial seeing" espoused by Leo Stein in his counter-Cubist *A-B-C of Aesthetics* (1927). By the 1930s, Wood's major stylistic transformation coincided with Art Deco adaptations of aerodynamics, as witnessed in the streamlined contours of such fantasy farmscapes as the recently resurrected *Plowing* of 1936 (Plate 24). The high degree of abstraction in this drawing came closer to that of the first generation American modernists than the polemics of Regionalism would dare acknowledge.

Not so preoccupied with literal depictions of a particular place as is generally alleged, the three leading midwestern Regionalists—Wood, Thomas Hart Benton, and John Steuart Curry—mulled over the relationships of their individual styles of painting to modern movements of abstract art. Curry's admiration for the drawing abilities of Matisse and Picasso could never outweigh his conservative loyalty to subject matter true to "American life, its spirit and its actualities." As for nonfigurative abstraction, he declared it obsolete by the mid-1930s: "At this time paintings of a purely decorative nature have little appeal. . . . I myself have had no struggle for or with a subject matter. Likewise I have not been worried by the fear that my art form would or would not fit the prevalent esthetic style."[1]

Although the triumvirate of Regionalism uniformly reprimanded American modernists for annihilating the human figure, at least two of them failed to resist the growing emphasis on reductive abstraction in conceiving and carrying out a picture. As the Urban Realists John Sloan and George Bellows had discovered, the avant-garde was too persuasive to defy altogether. And, in common with the Alfred Stieglitz alliance of abstract painters, Wood agreed that Paris School modernism had "added too many powerful tools to the kit of the artist to be forgotten."[2] Benton explained his inability to resist the influence of recent modernism in a broad art historical pronouncement: "The whole modern movement has been an exploration of the past. We have relearned that design is the important element in painting."[3] In spite of his deep dissatisfaction with his youthful, color-Cubist experiments based on the

Synchromism of his friend Stanton Macdonald-Wright (Figure 21), and his disdain of nonfigurative painting in general, Benton's mid-1920s series of articles for *Arts Magazine* advocated reliance on abstraction for "synthetically" devising compositions. "Form and the Subject," written in 1924, and his five-part series "Mechanics of Form Organization in Painting" (1926–1927) not only held that the basis for a work of art existed initially in the abstract but also hypothesized that an artist's singular familiarity with a subject as "historical material, if adequately represented, would cause the form itself to change."[4] Short of Gauguin's mystical visions, Benton visualized a synthesis of cultural meanings and pictorial configurations.

Although Wood was also growing dissatisfied with his early paintings by the time Benton published his articles, it could not have been a Cubist connection that bothered him. Quite the contrary: it was the "picturesqueness" of his "Impressionistic" style that made him uncomfortable (Figure 22). At one point he even experimented with painting a nonfigurative Expressionist abstraction to the accompaniment of a recording

21 Thomas Hart Benton
(American, 1889–1975)
Constructivist Still Life, 1917–1918
Oil on paper, 17 ½ x 13 ⅝ in.
Columbus Museum of Art, Columbus, Ohio
Gift of Carl A. Magnuson, 1963

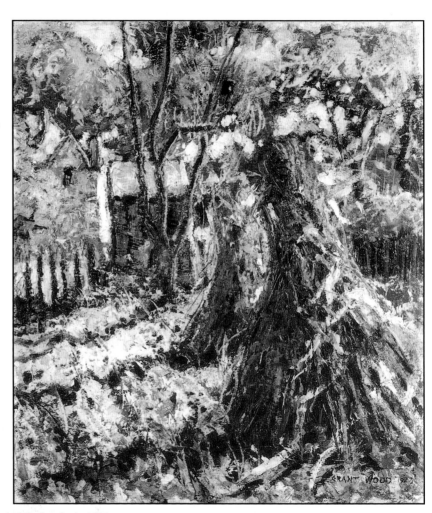

22 *Cornshocks,* 1928
Oil on composition board, 15 x 13 in.
Private collection
(Not in exhibition)

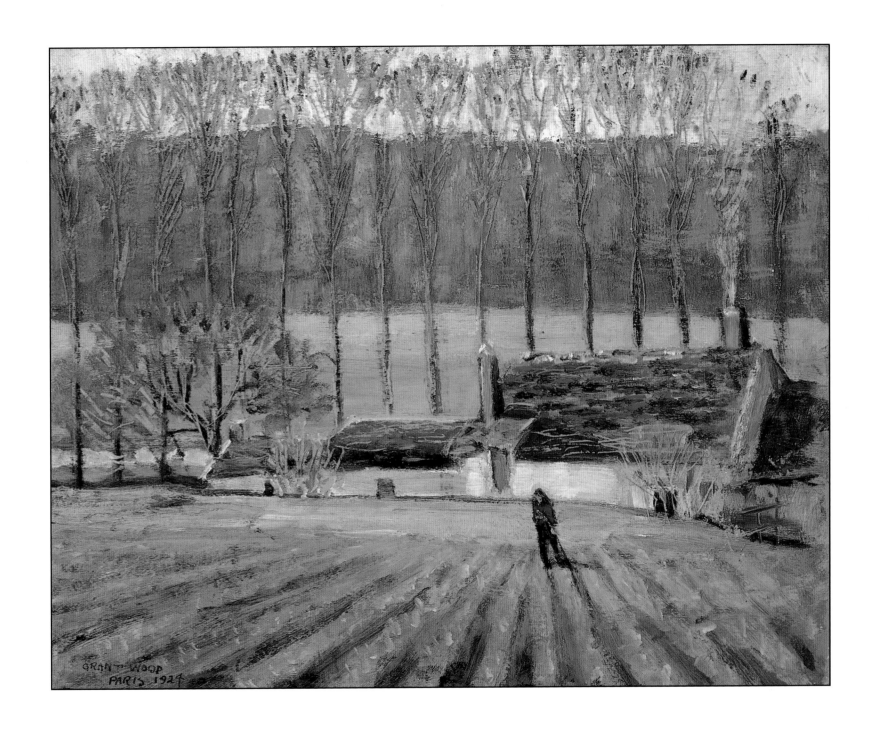

Plate 25
Truck Garden, Moret, 1924
Oil on composition board, 12 ½ x 15 ¾ in.
Davenport Museum of Art, 65.3

of modern romantic music.[5] Failing in that effort, he created a series of floral still lifes during the late 1920s in which he began to solve problems of design he had avoided for ten years by use of a painterly surface. Then, by the early 1930s, a precisely linear stylization distinguished his make-believe Iowa landscapes from anything he had done before. Although *Stone City, Iowa* (1930) was based on a direct study of a place with which he was thoroughly acquainted, he turned this village and its river valley site into a fantasy of curving contours, ornamental trees, and brightly patterned surfaces (Figure 10, Plate 13). Wood considered the "decorative adventures" of his commonplace rural surroundings—their inherent elements of abstraction—as the true origin of the most lasting quality in his work.[6]

Approaching Wood's career in search of abstractionist tendencies, one soon detects the control of decoratively patterned surfaces as a central goal, one that guided his efforts toward a "twentieth-century" style. In addition to his open eye for early modernist means of pictorial composition, he was attracted to early Renaissance paintings for their clear sense of design. This combination of interests indicates that the importance to Wood of learning basic processes, and not a mere attachment to the life of a region, contributed to his "anticolonial" stance against simply copying currently fashionable European subject matter and styles. Of greatest importance to the eventual independence of his aesthetic ideology, he shared an inclination among first generation American modernists to study and absorb American methods of composition.

In the wake of imported modernism, ostensibly on the wane by 1930, Wood claimed that a revival in depiction of American subject matter was taking place throughout the country. Although this was to be applauded, artists would need to distinguish themselves as inventive individuals and reject any return to outworn nineteenth-century academic techniques. A powerful tendency of the revival, according to Wood, would be toward a "literary feeling," the "story telling picture" being the "logical reaction from the abstraction of the modernists." As he hastened to point out, therein lay its greatest danger. The general public would continue to demand illustrations that it could understand without "mental exertion," leading to a return to the likes of such nineteenth-century favorites as "*A Yard of Puppies* and *The Spirit of '76.*" To avoid this reactionary extreme, Wood proposed the establishment of a decorative convention that would hold anecdotal details in check. With other progressive American painters such as John Sloan, he observed this positive limitation in paintings of sixteenth-century Italian, Flemish, and German masters:

> They are decorations first and story telling pictures afterwards, and the story is in no wise weakened by the decorative qualities. The story of American life of this period can be told in a very realistic manner, employing sympathy, humor, irony or caustic criticism at the will of the painter, and yet have decorative qualities that will make it class; not as an illustration, but as a work of fine art with the possibilities of living through the ages—if the decorative side is finely considered.[7]

In the months following his double triumph of *Stone City, Iowa* and *American Gothic,* Wood promoted his current style of painting as representing the "new movement" and paralleled its compositional inventions with the advent of Mission

furniture in his early youth. He enthusiastically applauded anti-Victorian principles of simplified design. But, he added,

> the mission period was only a clearing away period for better things to come. . . . A generation later we find art going through the same phases, Modernism instead of Mission. The clearing away period, with its simplification to the point of crudity, is showing signs of decline, and we are already looking forward to the newer, I hope, better things to come.[8]

A key consideration of what is modern in a twentieth-century painting is its surface clarity, or, more specifically, its flat-patterned abstractness, regardless of subject matter or lack thereof. In the nomenclature of leading American art educators during the first decades of the twentieth century, pictorial abstraction was equated with decorativeness. By reading *Craftsman Magazine* Wood, while still in high school, found his first up-to-date source of their concepts: a series of articles by the California art educator Ernest A. Batchelder, whose correspondence course in design Wood also completed. As if that were not enough, on graduation night in June 1910 he traveled by train to Minneapolis to enroll in a summer course Batchelder taught as a visiting instructor at the School of Design and Handicraft.[9]

In this course, following the chapters in his book *The Principles of Design*, Batchelder defined, demonstrated, and illustrated, using his own drawings and various historical examples (mostly Asian), "elementary line," "rhythm," "balance," and "harmony." These were to correspond with "tone," "measure" (size), and "shape" (Figure 23).[10] Applicable to either "ornamental" designs or "pictorial" compositions, Batchelder meant these principles to clarify and

control the interaction of line and mass, proceeding from the simple to the complex. As did the Harvard art educator Denman W. Ross, with whom he had studied in 1901, Batchelder disavowed illusionistic adherence to natural form and borrowed his teacher's basic distinctions between representation and design.[11] Representation—the recording of observed facts—was not intended to serve any decorative purpose. Pure design, on the other hand, amounted to "the arrangement of lines or masses in an orderly way for sake of their decorative value."[12] "Design in representation" occurs when the element of representation dominates but at the same time the arrangement of lines recognizes the value of the decorative. "Representation in design," on the other hand, permits design to receive first consideration and relegates representation to secondary status. Resemblance to some natural feature could

23 Illustration from Ernest A. Batchelder's book *The Principles of Design* (Chicago: Inland Printer, 1904)

very well remain but might be so abstract in compositional function that immediate identification would be difficult.[13]

A glance at examples of Wood's three-dimensional metalwork suggests that Batchelder's decorative design principles became second nature to him. Wood's whimsical *Lilies of the Alley* (Figure 24) thrives on a constantly changing interaction of lines and masses made up of twisted-wire stems and found-object flower blossoms. A gear or a wood clothespin loses its practical identity and performs as an abstraction of nature, free from literal translation. His symmetrical wrought iron candle holder (Figure 25), though more conventional in its craftsmanship and design components, underplays its function in three and a half square feet of line, shape, and moderately descriptive masses. That a candle might sit at its top is of little consequence to the decorative value of its "design in representation" or "representation in design."

In line of succession, it is clear that Batchelder's basic frame of reference, and in turn Wood's, may be traced through Denman W. Ross to

24 *Lilies of the Alley* (with clothespin), c. 1922–1925
Mixed media, 11 x 11 ¼ x 7 in.
Cedar Rapids Museum of Art, Cedar Rapids, Iowa
(Not in exhibition)

the Fenollosa-Dow system of art education. Ross met Arthur W. Dow in Boston in 1898, and they traveled to Venice together, painted side by side, and exchanged views on art.[14] Under the spell of Ernest F. Fenollosa, Curator of Japanese Collections at the Museum of Fine Arts, Boston, both Ross and Dow believed that East Asian art, particularly Japanese *Ukiyo-e* painting and printmaking, encompassed "primary" or "abstract" art principles. To them, imagination implied an exact, sharply focused singularity, a "fundamental unity of line, mass and color."[15]

Dow's manual of art exercises for students and teachers aimed at "a better method of teaching than the prevailing nature-copying."[16] The book's success may be measured by its longevity: first published in 1899 and revised and enlarged in 1913, it was published by Doubleday in more than twenty editions until the

25 Single candle holder, c. 1924
Wrought iron, 42 x 12 in.
Cedar Rapids Museum of Art,
Cedar Rapids, Iowa
(Not in exhibition)

early 1940s. In it Dow organized Fenollosan principles of abstract harmony and pure art as a trinity of line, *notan* (a Japanese term for light and dark patterns), and color (Figure 26). Regretting the divorce of decorative and representative elements in Western art, he had discovered their continued integration in Japanese art through the prints of Hokusai: "The Japanese know of no such divisions as Representative and Decorative; they conceive of painting as the art of two dimensions; an art in which roundness and nature-imitation are subordinate to the flat relations."[17]

26 Illustration from Arthur W. Dow's book *Composition: A Series of Exercises in Art Structure for the Use of Students and Teachers* (Garden City, N.Y.: Doubleday, Page, 1913)

In 1891, the year Dow met Fenollosa, he adopted Fenollosa's central concept, the Whistlerian belief that beauty in art relied primarily on formal elements of abstraction. Because "its essence is pure beauty," music provided the most perfect model for the fine arts, it being essentially an art of abstract, synthetic arrangements of form. In compliance with this often-made parallel, "space-art" might aspire to and be valued as "visual music."[18] Line, *notan*, and color, indispensable to "all forms of space-art, whether representative or decorative, architectural, sculptural or pictorial," were to be applied and integrated according to "a few simple principles."[19] Dow was confident that from this easily grasped, democratized aesthetic, "a powerful, distinctly American school" could arise that would be responsive to the history and character of the country.[20] A more pronounced anticipation and obvious source of inspiration could not be found for the fundamental ideals, if not the respective practices, of Wood, Benton, and Curry.

Dow explained the progression of line, *notan*, and color as interdependent units of a hierarchical order. Line would always be the initial determinant of composition and the measure of its ultimate success or failure: "all kinds of line harmony, beauty of contour, proportion of spaces, relations of size—all drawing whether representative or decorative."[21] The second step of the learning process, *notan*, the distribution of values, achieves a balanced, harmonious order. Distinct from rendered effects of light and shadow, it is instead "a placing

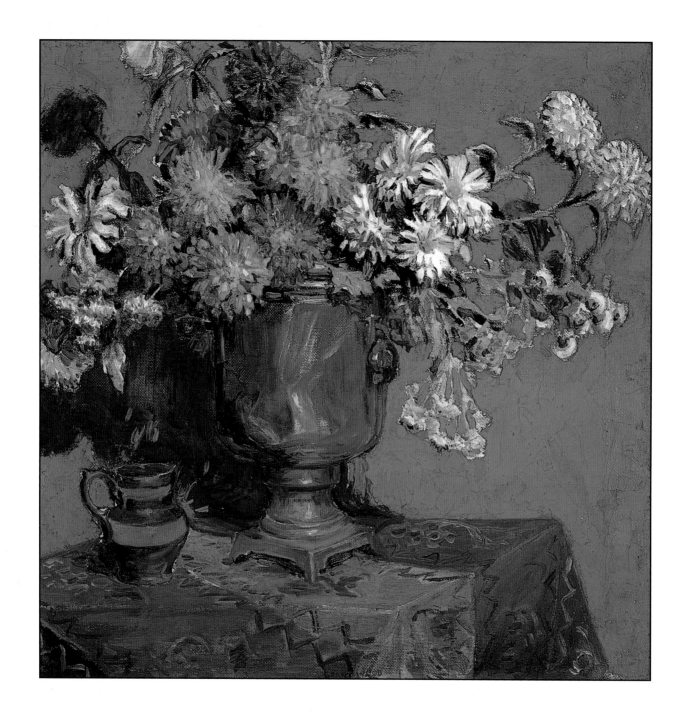

Plate 26
Mixed Bouquet on a Covered Table (Flowers for Alice), 1928
Oil on canvas, 21 ½ x 22 in.
On loan to Brucemore, Inc., Cedar Rapids, Iowa
Private collection

together of masses of dark and light, synthetically related."[22] Whether based on two or many tones, the beauty associated with *notan* necessarily implies abstract, pictorial space: "We do not wish to be misunderstood as advocating the entire omission of shadows, or of modelling. . . . But the flat relations are of first importance; in them must lie the art of painting."[23] On this central point hinges modernist abstraction, including that of Wood. Regardless of color intensities, he drew and painted compositions emphasizing relationships of value rather than of hue. The clustered lights and darks of *Mixed Bouquet on a Covered Table (Flowers for Alice)* (Plate 26) create a "beautiful arrangement" that loosens left and right into a "decorative" surface pattern more elaborate than the patterned table-cloth. Modulated ochers and touches of red scattered from top to bottom provide the only chromatic contrasts to the richly textured turquoise color field of the wall.

In *Mixed Bouquet in White Vase* (Plate 27), *Delphiniums in White Vase* (Plate 28), and *Zinnias* (Plate 29), robustly rendered pottery containers anchor the compositions. In these paintings, the generous proportions of the vase or crock, placed on a tabletop or a shelf against a wall or, in the case of *Zinnias*, cropped at the bottom, provide a solid contrast to the energetically impastoed flower, stem, and leaf forms bursting beyond the upper and outer edges of the picture plane. Sharply contrasted hues and values flatten the illusion of tangible blossoms. The immediate "field" of painterly shadows within the bouquets, or of larger cast shadows and illuminated areas of wall, refuses to remain behind the flower "figures." It too claims the picture surface as a complex of pronounced shapes in the abstract. Thus Wood's floral paintings evoke

the basic dynamic of modern pictorial art in their "push-pull" tensions as solid forms and flat shapes vie to share the vital zone of attention between picture plane and picture surface.

Beyond naming color as the third of the structural elements, cautioning the student to coordinate it with *notan,* and citing a few historical examples of its best use, Dow had little to say on the subject in the 1899 edition of his manual. In fact, from the start he signaled his intent to treat only line and *notan.*[24] But both his intervening *Theory and Practice of Teaching Art,* a teacher's handbook published in 1908, and the 1913 edition of *Composition* (concurrent with Wood's decision to become a painter) devote an entire section to color. As Dow frankly admitted, however, color remained "baffling; its finer harmonies, like those of music, can be grasped by the appreciation only, not by reasoning or analysis."[25]

Likewise, basic composition, ironic as it may seem, received no systematic coverage in Dow's manual until the expanded version of 1913.[26] To begin the art of picture making, an understanding of "subordination" and "rhythmic repetition" would suffice; the refinements of "symmetry," "opposition," and "transition" could follow. In the exercise section of "Line Composition part VII—Landscape Arrangement," the subject matter suggestions read as if they had been dictated to Wood: "A street where there is variety in the size of buildings and trees" or "ranges of hills, spires and pinnacles, clumps of large and small trees, clusters of haystacks" (Plate 13). Dow also prescribed form reduction in the service of a decorative scheme of images: "Take any landscape that has some good elements in it, reduce it to a few main lines and strive to present it in the most beautiful way."[27] It would seem that this is precisely what Wood was trying to accomplish in his 1919 paintings *Fall*

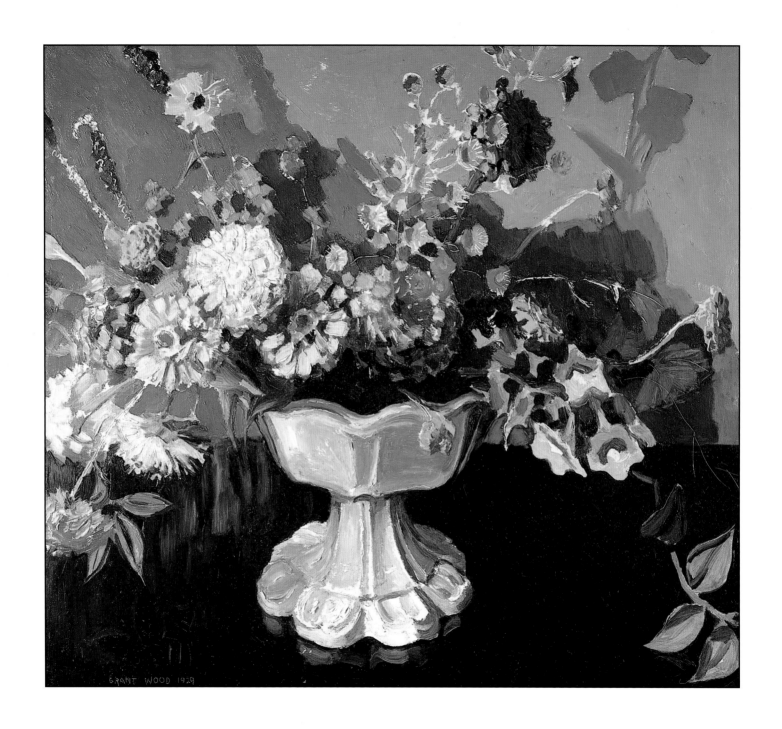

Plate 27
Mixed Bouquet in White Vase, 1929
Oil on Masonite panel, 20 x 22 in.
Private collection
(Not in exhibition)

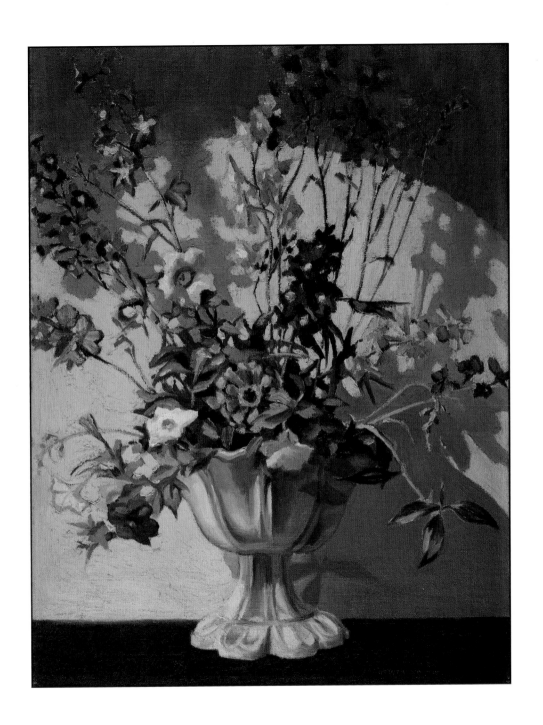

Plate 28
Delphiniums in White Vase, 1929
Oil on canvas, 24 x 18 ¼ in.
Private collection

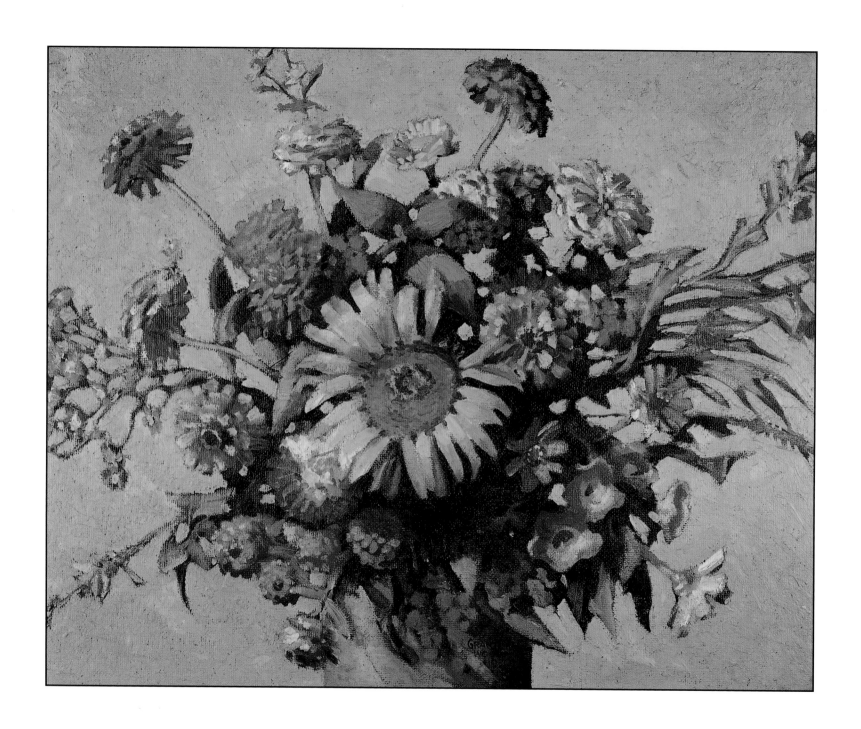

Plate 29
Zinnias, 1930
Oil on composition board, 24 x 30 in.
Private collection

27 *Fall Landscape,* c. 1919
Oil on composition board, 13 x 15 in.
Private collection
(Not in exhibition)

28 *Feeding Time,* c. 1919
Oil on composition board, 6½ x 8½ in.
Private collection
(Not in exhibition)

Landscape and *Feeding Time* (Figures 27 and 28). In each, the main lines of silhouetted tree limbs bend and bow to create light, positive shapes thick in paint. In the latter, the trees' decorative abstractness is matched by the shapes of four pigs over which is scratched a surface pattern of vertical and horizontal lines.

If such advice were not enough to inspire the fledgling painter, this same section of *Composition* compares the linear interplay of land and tree forms to that of a familiar woven fabric: "Looking out from a grove we have trees as vertical straight lines, cutting horizontal lines, or nearly so. Leaving small forms out of account we have in the main lines an arrangement of rectangular spaces much like gingham and other simple patterns."[28] Such an analogy, in keeping with Wood's taste for the commonplace, strengthens the assumption

that he developed his means of pictorial composition under the pervasive influence of Dow, if indirectly through Batchelder. Regardless of its original source, his adherence to reductive abstraction affiliated him with the first generation of American modernists.

Dow counted among his students and proponents several painters, photographers, and critics who were to be identified with the American vanguard during the first quarter of the twentieth century.[29] Photographer Gertrude Käsebier, a colleague at Pratt Institute in Brooklyn, was among the first photographers affiliated with the Photo-Secession Gallery, as was Alvin Langdon Coburn, who enrolled in Dow's summer class at Ipswich, Massachusetts, in 1903. Pamela Coleman Smith, the first American painter to be exhibited by Stieglitz at 291 (in January 1907), had attended Dow's classes at Pratt between 1893 and 1899. The painter Max Weber, who studied with Dow at Pratt as *Composition* was first coming into print, taught his mentor's principles at the State Normal School in Duluth, Minnesota. After two years as head of its Department of Drawing and Manual Training, he left the school in 1905 to study in Paris, an undertaking for which, he would claim, Dow had prepared him. Once abroad, however, Weber strayed from the anti-Imitation principles of *Composition* by appropriating avant-garde styles. After discovering Cézanne and enrolling in a painting course offered by Matisse, he attached himself to Picasso and the Futurists. Their combined influence qualified his derivative paintings for Regionalist attacks against the "colonial spirit" of stylistic dependence on Europe.[30]

Georgia O'Keeffe learned of the Fenollosa-Dow system during a drawing class she took from a disciple of Dow, Alon Bement, at the University of Virginia in the summer of 1912; she studied under the master teacher himself at the Department of Fine Arts at Columbia University's Teachers College in

1914–1915 and during the spring term in 1916. O'Keeffe credited Dow with strengthening her powers of pictorial composition, especially in her experiments in abstracting flowers and leaves into a rectangular format (Figure 29).[31]

As demonstrated in the illustrations throughout *Composition* and *Theory and Practice of Teaching Art,* success in composing such subject matter characteristically involved asymmetry and, often, a close-up view of the image partially cut off at the edges (Figure 26). Subsequent to her initial nonobjective abstractions of the late 1910s, it was through this process of object-oriented configuration, shared with photographers Paul Strand and Imogen Cunningham, that O'Keeffe achieved her most monumental single-flower abstractions.

Visual lessons in *Composition* also correspond to Arthur Dove's highly personal, abstract style of painting, which climaxed at the very beginning of his career (Figure 30). That Dow provided more of a stimulus to this rapid development than did the 1911 Picasso exhibition at 291 is indicated by the distinctly

decorative abstraction of Dove's oils and pastels as early as 1912. In a statement to Chicago art collector Arthur Jerome Eddy for his book *Cubists and Post-Impressionism* (1914), and reiterated to Samuel Kootz for his *Modern American Painters* sixteen years later, Dove maintained that "all good art" is guided by a few fundamental principles of form and composition in the abstract, and that he, as Wood later did, had abandoned "more disorderly

29 Georgia O'Keeffe (American, 1887–1986)
 Corn, Dark I, 1924
 Oil on composition board, 31¾ x 11⅞ in.
 The Metropolitan Museum of Art
 Alfred Stieglitz Collection, 1950
 Photograph by Malcolm Varon
 © 1987 The Metropolitan Museum of Art

30 Arthur G. Dove (American, 1880–1946)
 Abstraction No. 3, 1910
 Oil on composition board, 9 x 12 in.
 Private collection

methods of impressionism."[32] In tune with Dow, Dove developed a trio of basic precepts to guide his creative instincts toward a pictorial process that was abstract in spirit and substance. Although he was never a colorist in the manner of Sonia and Robert Delauney's Orphism or its American version, Synchromism, he assigned color—the most problematic element for Dow—a prominent role. In union with form and line, a triad of hues, plus black and white, originated with "the condition of light," an aura Dove contemplated as unique to any object from which his paintings evolved.[33] Material possession of limbs, foliage, shadows, and surfaces, of all volumes and masses, would thereby diminish at a level of nonobjective abstraction higher than that of either Wood's *Cocks-Combs* (Figure 31) or O'Keeffe's *Corn, Dark I*. But, to his credit, Wood's most abstractive moments advanced Dowian means of expression beyond the narrow limits of conventional anecdotal realism, as when the shapes of shadows combine with those of cockscomb stems and flared leaves to create a dynamically patterned design at the expense of a faceless madonna and child.

As may be judged by frequent references to Dow in Stieglitz's art periodical *Camera Work* and by the adoption of Dow's terminology and aesthetic standards by the prominent art critics–historians Charles Caffin and Sadakichi Hartmann, he seems to have contributed significantly to the progress of art criticism, advancing it from purely descriptive accounts to formal analysis. This American-spawned modernist sensibility was not lost on Leo Stein, who was indebted to Bernard Berenson for his early appreciation of Cézanne. His later bias against the Synthetic Cubist works of Picasso and the ornate figurations of Matisse emerged as his ideas and vocabulary of "pictorial seeing" acquired an increasing resemblance to the Fenollosa-Dow instructions on abstraction.

In time for the major changes comprising Wood's final development, Stein's *A-B-C of Aesthetics* appeared in 1927, the year Wood began his floral still life series. Stein saw a good picture as "something that one looks

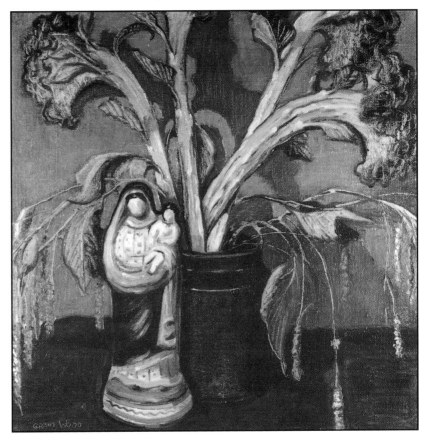

31 *Cock's-Combs*, c. 1927–1928
Oil on canvas, 21 ½ x 21 ¼ in.
Private collection
(Not in exhibition)

into, but . . . keeps out of."[34] Whether an interior or an exterior, its subject matter must constitute "a composed abstraction," with some degree of distortion imposed on "inventorial things."[35] Petals, leaves, and stems, for example, must unite across the surface as active components of a work. Whereas success in flat composition was quite common, a true painting, as opposed to an anecdotal illustration or a stenciled pattern, must also be rhythmically arranged into a cohesive spatial order. The key to all else is the "compositional relation

of depth to the flat plane of the picture's surface."[36] Diagonal—that is, perspective—planes should reciprocate with transverse planes, like the successive layers of scenery on a stage:[37]

> A picture could, in fact, be conceived as made up of transverse planes like successive layers of theater scenery, in which the object would be to emphasize the intervals, rather than, as in naturalistic stage scenery, to blend and so obscure them. These transverse planes are the means for creating a series of intervals and therefore for producing rhythmic movement in the deep dimension of the picture.[38]

Complementing the stage analogy to his mature style of painting, Wood occasionally designed sets for the Cedar Rapids community theater in the late 1920s and early 1930s. It was during those years that he created his most fanciful farmscapes. As perfect illustrations of Stein's most instructive phrases, the rhythmically related intervals of Wood's breakthrough painting of 1929, *Black Barn* (Figure 32), followed by those of his oil study for *Stone City, Iowa* (Figure 10), maintain a continuous back-and-forth movement—what Stein calls a "rhythmic throwback to the frontal plane."[39] While Picasso and Braque shunned mere surface decoration, they, in Stein's opinion, never so effectively controlled the relationship of forms in recessive space: "The departure from design on a flat surface leads to all these difficulties of design in depth, which the modern artists have tried to solve."[40]

Stein also stressed a trait Batchelder discussed as good "curve sense," something Wood eventually applied in such later landscapes as his great, green stretch of a painting, *Spring Turning* (Plate 4), and in the rather vertiginous drawing of

32 *Black Barn*, 1929
Oil on composition board, 9½ x 13 in.
Private collection
(Not in exhibition)

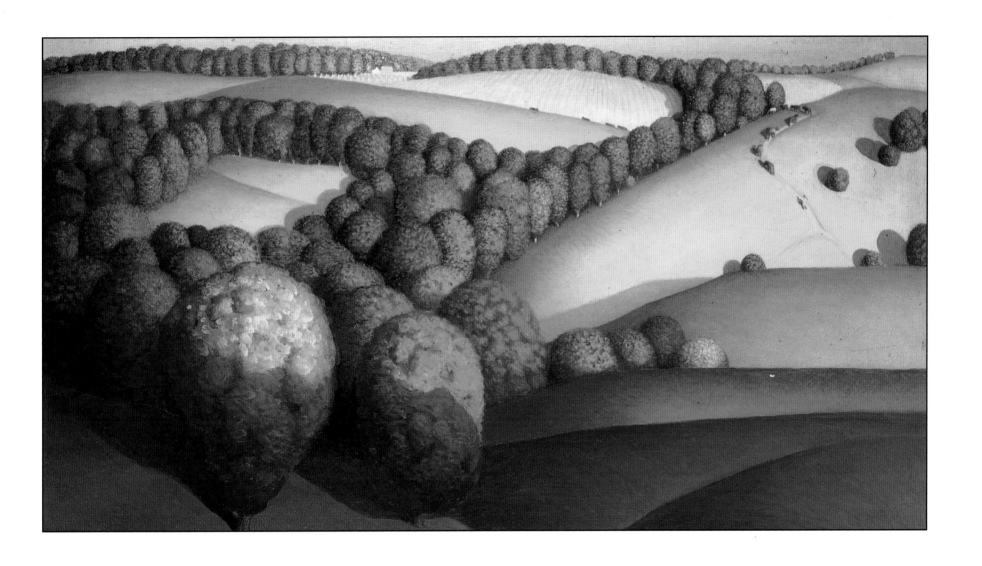

Plate 30
Near Sundown, 1933
Oil on canvas, 15 x 26 ½ in.
Spencer Museum of Art, The University of Kansas
Gift of Mr. George Cukor, 59.70

Plate 31
Death on the Ridge Road, 1935
Oil on Masonite panel, 32 x 39 in.
Williams College Museum of Art
Gift of Cole Porter, 47.1.3

the same year, *Plowing* (Plate 24). In their wide-open expanses of space, the broad surfaces of undulating, earth mother ground swells acquire decorative patches of warm brown soil at the hands of the plowmen. The painter, with the lasting encouragement of his foremost teacher and the theoretical approval of a contemporary critic, amplified and manipulated visual information that to him might have seemed too familiar. Surrounding "hill country becomes transformed," abstracted beyond the picturesque:

> The lines are made to serve in a definite way instead of rolling
> accidentally. By moving the pictorial planes backward or forward, masses
> are flattened or developed at will. The plasticity of natural materials is in
> fact almost infinite, if only one has learned to mould them.[41]

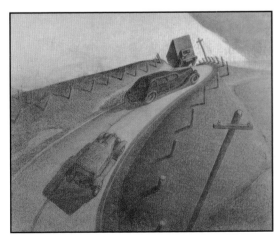

33 Study for *Death on the Ridge Road*, 1934
Pencil and chalk on paper, 31 ¼ x 39 in.
Private collection

The "curve of force," or, to borrow John Ruskin's term, the "infinite curve," had been stressed by Batchelder as expressive of growth, a sign of fecund vitality.[42] If motivated by the "play impulse" ostensibly enjoyed by Wood, a vigorous imagination would rekindle the legendary innocence and pleasure witnessed in "primitive" work and in the work of medieval craftsmen.[43]

Romantic historicism aside, it was arguably a play impulse that activated the dynamic curve sense of Wood's major works and hastened them into the streamlined period of Art Deco. In line with industrial designers who by the mid-1930s had modeled the modern automobile, airplane, and ship using the calculations of aerodynamics, Wood superimposed streamlined compositions over his system of "thirds," an intricate grid pattern of precisely drafted verticals and horizontals intersected with diagonals (Figure 34).[44]

34 *March*, 1941
Charcoal and white chalk on paper, 9 x 12 in.
Davenport Museum of Art
Gift of Nan Wood Graham, 60.1014
Grid with diagonals superimposed to illustrate Wood's "thirds" method of composing a picture

Now motivated by a mechanistic aesthetic that annuls the commonplace, Wood's methodical process minimized the "applied ornaments" of local color. Through exaggerations of man-made angles and rounded topography, it stylized the inherent nature of even the most desolate segments of eastern Iowa farmland into an appealing modernist abstraction, Regionalism notwithstanding.

Notes

1. John Steuart Curry, public address sponsored by the Art Association of Madison, Wisconsin, on his assumption of the position of artist-in-residence at the University of Wisconsin, 1937. The address is quoted in full in Laurence E. Schmeckebier, *John Steuart Curry's Pageant of America* (New York: American Artists Group, 1943), 240–99.

2. "Grant Wood Explains Why He Prefers to Remain in Middle West in Talk at Kansas City," *Cedar Rapids Sunday Gazette and Republican,* March 22, 1931.

3. Ruth Pickering, "Thomas Hart Benton on His Way Back to Missouri," *Arts and Decoration* 42 (February 1935): 20.

4. Benton also commented on his methods of this period in a later article in *Creative Art* magazine. Thomas Hart Benton, "My American Epic in Paint," *Creative Art* 3 (December 1928): xxxi–xxxvi. Matthew Baigell published the earliest art historical accounts of Benton's development of figurative abstraction in theory and practice. See Matthew Baigell, *Thomas Hart Benton* (New York: Harry N. Abrams, 1975). In addition to his monograph on Benton, see Matthew Baigell's "Thomas Hart Benton in the 1920s," *Art Journal* 4 (summer 1970): 422–29. The emergence of Benton's "mechanics of form" out of his Stanton Macdonald-Wright Synchromist period ten years earlier is discussed in Victor Koshkin-Youritzin, "Thomas Hart Benton: 'Bathers' Rediscovered," *Arts Magazine* 49 (May 1980): 98–102. For evaluations of Benton's pro-abstraction leanings, see Gail Levin, "Thomas Hart Benton: Synchromism and Abstract Art," *Arts* 4 (December 1981): 144–48, and Hilton Kramer, "Benton: The Radical Modernist," *New York Times,* January 10, 1982.

5. In the fall of 1922 or the spring of 1923, Grant Wood is reported to have exhibited a totally nonfigurative abstract painting at the Cedar Rapids Art Association. He called it *Song of India.* Allegedly, it consisted of swirls of oil paint in contrasting colors that he applied to burlap while playing Rimsky-Korsakov's composition on a Victrola. Interview with Mrs. Marvin Cone, Cedar Rapids, Iowa, April 13, 1981. H. W. Janson referred to this interlude in Wood's career as "a brief and uncomfortable attempt at abstraction following his first visit to Paris." H. W. Janson, "Benton and Wood: Champions of Regionalism," *Magazine of Art* 39 (May 1946): 198.

6. "Grant Wood Helps Young Artists Develop Technique," *Daily Iowan,* November 3, 1935.

7. "Grant Wood Explains," *Cedar Rapids Sunday Gazette and Republican,* March 22, 1931.

8. Ibid.

9. As recalled by Wood's late sister, Nan Wood Graham, and brother, Frank Wood, during interviews with the author.

10. Ernest A. Batchelder, *The Principles of Design* (Chicago: Inland Printer, 1904), 8–10.

11. In the preface to his *Principles of Design,* Batchelder forthrightly acknowledged Ross's influence. Although a much less intellectual systematization of design than that published by Ross in his *Theory of Pure Design: Harmony, Balance, Rhythm* (1907), Batchelder's *Principles of Design* includes certain concepts and terminology that apparently originated with his teacher.

12. Batchelder, *Principles of Design,* 4.

13. Ibid., 5–6.

14. Marianne Martin, "Some American Contributions to Early 20th Century Abstraction," *Arts Magazine* 10 (June 1980): 158–65.

15. Ernest Fenollosa, *Imagination in Art* (Boston: Boston Art Students Association, 1894), 7, as quoted in Martin, "Some American Contributions," 159.

16. Arthur W. Dow, *Composition: A Series of Exercises in Art Structure for the Use of Students and Teachers* (Garden City, N.Y.: Doubleday, Page, 1899), 5. (Revised edition published in 1913.)

17. Ibid., 60.

18. Ibid., 5.

19. Arthur W. Dow, *Theory and Practice of Teaching Art* (New York: Columbia University Press, 1908), 4.

20. Frederick C. Moffatt, *Arthur Wesley Dow* (Washington, D.C.: Smithsonian Institution Press, 1977), 50.

21. Dow, *Theory and Practice of Teaching Art,* 5.

22. Dow, *Composition* (1899), 37.

23. Ibid., 52.

24. Ibid., 15.

25. Dow, *Composition* (1913), 100.

26. Moffatt, *Arthur Wesley Dow,* 63. Dow, however, is thought to have established a routine of compositional principles by 1892.

27. Dow, *Composition* (1913), 47.

28. Dow, *Composition* (1899), 25.

29. Moffatt, *Arthur Wesley Dow,* 95. In addition to being an instructor at Pratt Institute, he held summer classes at Ipswich, Massachusetts, and, beginning in 1903, served for many years as director of the Department of Fine Arts at Teachers College, Columbia University.

30. Lawrence W. Chisolm, *Fenollosa: The Far East and American Culture* (New Haven, Conn.: Yale University Press, 1963), 237.

31. Jack Cowart, Juan Hamilton, and Sarah Greenough, eds., *Georgia O'Keeffe: Art and Letters* (Washington, D.C.: National Gallery of Art, 1987), 3 n. 275. For a consideration of Dow's influence on O'Keeffe, see Katherine Kuh, *The Artist's Voice* (New York: Harper and Row, 1962), and Sandra Fillin Yeh, "Innovative Moderns: Arthur G. Dove and Georgia O'Keeffe," *Arts Magazine* 56 (June 1982): 68–72.

32. Quoted in Samuel Kootz, *Modern American Painters* (New York: Brewer and Warren, 1930), 37. For the best treatment to date of Dove's awareness and assimilation of Dow's teachings, see Arlette Klaric, *Arthur G. Dove's Abstract Style of 1912: Dimensions of the Decorative and Bergsonian Realities* (Ph.D. diss., University of Wisconsin–Madison, 1984).

33. Ibid., 37.

34. Leo Stein, *A-B-C of Aesthetics* (New York: Boni and Liveright, 1927), 156.

35. Ibid., 118–28.

36. Ibid.

37. Ibid., 163.

38. Ibid., 169.

39. Ibid., 166.

40. Ibid., 171.

41. Ibid., 176–77.

42. Batchelder, *Principles of Design,* 34, fig. 15.

43. Ibid.

44. By dividing each edge into thirds and crisscrossing diagonals from point to point through the intersections of nine equal oblongs, Wood contrived an easily learned system vaguely comparable to the plane geometry of determining a "golden section" popularized as "dynamic symmetry" by the art educator Jay Hambidge. In an interview early in 1984, noted African American sculptor and printmaker Elizabeth Catlett, an M.F.A. student under Wood at the University of Iowa, described the system: "He made us work step by step; he separated the whole thing. First we got an idea, and we did a drawing, a line drawing. Then we did dynamic symmetry, which he taught us. You divide up the space, and you use a lot of lines, straight lines and diagonal lines. And you project your drawing over that, so that it changes very slightly, but it fits onto one of the lines which you've made. So then, instead of just an ordinary drawing, you got a dynamic drawing, with slight distortions. But the distortions strengthened the drawing." Elizabeth Catlett, interview with Clifton Johnson, Amistad Research Center, Tulane University, New Orleans, January 5, 1984.

Plate 32
Four Seasons Lunettes: Summer, c. 1922–1925
Oil on canvas mounted on board (arched frame), 16⅛ x 29⅛ in.
Cedar Rapids Community School District, Iowa
Photograph courtesy French Studios, Cedar Rapids, Iowa

Plate 33
Four Seasons Lunettes: Autumn, c. 1922–1925
Oil on canvas mounted on board (arched frame), 16⅜ x 45⅝ in.
Cedar Rapids Community School District, Iowa
Photograph courtesy French Studios, Cedar Rapids, Iowa

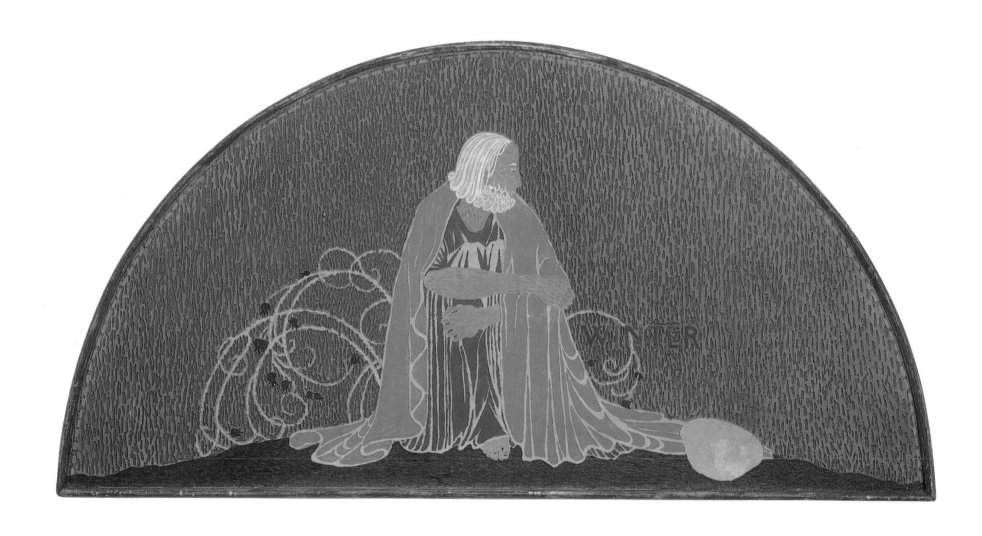

Plate 34
Four Seasons Lunettes: Winter, c. 1922–1925
Oil on canvas mounted on board (arched frame), 19 ½ x 39 ¼ in.
Cedar Rapids Community School District, Iowa
Photograph courtesy French Studios, Cedar Rapids, Iowa

GRANT WOOD: A TECHNICAL STUDY

BY JAMES S. HORNS AND HELEN MAR PARKIN

Knowledge of Grant Wood's painting materials and techniques has been largely anecdotal, based on accounts given by the artist during his lifetime or by colleagues and family after his death. As a supplement to these accounts, this essay, based on examination of a number of paintings Wood produced between 1924 and 1941, represents the first technical study of the artist's work. The purposes of this study were to identify the materials used, including supports, ground, paint films, and coatings; to describe the ways in which these materials were used; and to determine the relationship between technique and painting style. A number of paintings of Wood's mature style, after 1928, were studied in conservation laboratories. In addition, many others from the 1920s and 1930s were examined in gallery settings.[1]

The paintings Wood completed before 1929 vary widely in appearance and purpose. Many are somewhat Impressionistic, reflecting the type of pictures he might have seen on his early trip to Paris, but are technically similar to scenes he painted around Cedar Rapids prior to 1920. The paint was applied *alla prima,* directly to the support, often with no intervening ground. Preliminary drawings, when present, are sketchy and were intended as simply a laying in of general compositional forms. There is a spontaneity of paint handling in keeping with the intent of the image. During this period, Wood also produced carefully studied paintings, such as *Adoration of the Home,* with its allegorical design, and the *Four Seasons Lunettes* (Plates 32–34), which have a calculated decorative intent. After Wood traveled to Munich in 1928, his style changed quickly to tightly constructed, carefully executed scenes of life in Iowa. The development of his best-known paintings of this period involved a carefully prepared and often toned ground layer, a detailed drawing transferred from a finished study, careful application of small brush strokes of paint to conform to the drawing, and extensive use of final glazes to complete the modeling and color effects. A study of the methods and materials of these later paintings, which are markedly different from those of previous years, provides an understanding of the extent to which Wood used his technique to realize his artistic intentions.

Early Paintings

The paintings most characteristic of Grant Wood before approximately 1929 are the relatively small landscapes and city scenes painted near his home in Cedar Rapids, such as *Indian Creek,* or on trips to Paris. These paintings were most often executed on pulpboard panels that could be carried easily to locations for sketching *en plein air.* The thick, fluid paint was applied in a rich paste, with brush marking clearly defined. In some areas, a hard object, such as the end of a brush or a palette knife, was drawn through the wet or semi-dry paint to create additional texture or compositional lines. The surface of the panel, where not covered by paint or where revealed by scratching, was evidently intended to show as part of the finished design. Drawing lines, where visible, appear to have been applied to block in the composition, not to create a detailed preliminary design. These paintings generally seem to have been finished in one stage, without the benefit of reworking or revision.[2]

In contrast to the landscapes, *The Spotted Man* (Plate 8) was painted on a medium-weight twill-weave linen fabric. The ground, which appears to have been commercially applied, has been identified as primarily lead white.[3] The paint was applied as a rich paste in many layers, using a broad, pointillist technique of short brush strokes with low to medium impasto. A thin varnish coating, applied over abrasion, covers the surface.

Wood began the painting while studying at the Académie Julian in Paris in 1924, then reworked it after returning to the United States, applying smaller brush strokes over the existing design to refine the surface. The careful planning and deliberation involved in executing the design are clearly evident, but the painting belongs unmistakably to Wood's early work.

Other compositions produced during this period also show careful planning and execution of the design. A major achievement in this regard is the stained glass window, completed between 1927 and 1929, created for the Veterans Memorial Building in Cedar Rapids. Full-scale finished drawings of the final composition were made and followed closely in the completion of the project. The window represents an important early example of Wood's ability to conceptualize and develop a formal composition.

Interest in Glazing

During the 1920s, Wood began to show some interest in glazing as part of the construction and finishing of his paintings. The use of glazes was to become an essential part of his later paintings. In the middle of the decade, he painted a series of murals for rooms in hotels in several Iowa cities that came to be known as the Corn Room murals. These large-scale compositions were painted on canvas (primed with lead white paint)[4] adhered to the walls, creating an effect for the viewer of being surrounded by an Iowa landscape. The designs were broadly painted, and a medium-rich glaze appears to have been an integral part of the construction. Carl Eybers Jr., who as a boy assisted Wood for a short time in his work on the Corn Room murals in the Martin Hotel in Sioux City, recounted his recollections of Wood's glazing methods in an interview in 1979:

Just a glaze. That's a transparent color. The underground was already there, then [Wood] put the transparent color on. Then, he worked in this wet paint, wiping it off and putting a little more on here and there and working it with a dry brush. You wouldn't believe. Just a few swipes of his thumb and a dry brush and then there was a rabbit sitting there or a corn stalk. It was just fantastic![5]

Eybers maintained that the paintings were done in the glaze color only. However, though the paintings do appear to make extensive use of transparent, glazelike colors, areas of solid paint are also evident. Examination of cross

35 Photomicrograph[6] of embedded paint cross section from *Indian Creek* showing pigmented and glaze layers (approximately 160x)

sections reveals transparent or lightly pigmented layers over and between more solid paint layers.[7] Since Eybers worked on the project for only a day and a half, he may not have been present when details were added.

Another interesting example of Wood's early use of glazes is found in a small painting of Indian Creek dated by James Dennis to 1928 (collection of Clifford and Elizabeth Hendricks). Although in many ways this painting is similar to other landscapes of the 1920s, it clearly was produced in several stages. The final surface includes areas of transparent, pigmented glazes as well as an overall yellowed oil layer containing little or no pigmentation. The pigmented and unpigmented layers are intermixed, and much of the pigmented glaze has

36 Photomacrograph of *Indian Creek* showing shrinkage crackle caused by incompatibility of layers and uneven drying

pulled into distinct islands, resulting in a broad pattern of shrinkage crackle (Figures 35 and 36). Such a pattern suggests that the layering of paint and glazes involved some stresses between incompatible drying layers, as also may be seen in later paintings that have glazes and medium-rich layers. In addition, this painting shows evidence that it was placed in a frame (which marked the soft undried paint at the edges), then removed and reworked, with the glazes added at the final stage. Perhaps this version of *Indian Creek* can be seen as part of a transition to the paintings of the 1930s, in which Wood used glazes in a purposeful way in the finishing of his paintings.

Mature Paintings: 1929–1941

Wood's experience in design, paint handling, and glazing during the 1920s was important to his development in the next decade. After 1928, he constructed his paintings in a very deliberate way, with careful attention to planning and design of the composition and finishing of the painting to this design. The supports are solid panels or laminate structures designed to be inflexible. The grounds are white layers of varying thickness and texture, often toned with thin washes of color. In some cases, preparatory drawings were made, then transferred to the ground. Numerous layers of oil and resinous paint were then applied to build up the design, which became more refined and precise with each successive layer. Glazes were used to complete the modeling and color effects.

American Gothic

A review of the methods and materials used in *American Gothic* (Plate 16), Wood's pivotal work of 1930, provides a useful example of his technique in the 1930s. The support is layered pulpboard over which a white ground

has been applied with broad brush strokes, visible as curving lines of surface texture in the painting. There appears to be a thin, warm tone over the white ground. Black drawing lines, which are crumbly in texture and were identified as possible lamp black,[8] are clearly visible in many areas over the ground. In the upper section of the house, the pattern of boards and battens is defined by black lines visible in the final design (Figure 37). For the most part, the drawing has been followed in the final composition. Changes are visible, however, and seem to have been made after the first stage of painting was complete. For example, the upper roof line of the porch has been lowered to extend the vertical pattern of the upper half of the house. A chimney, visible at

upper left in the drawing (Figure 38) and in the x-radiograph, has been painted out and a slender spire added just to the right.

The paint was applied in multiple layers in varying textures. In some areas, such as the house and the man's overalls, the paint is a rather rich paste that retains brush marks and leaves islands of ground visible around the strokes (Figures 37 and 39), an application reminiscent of some of Wood's earlier

38 Study for house in *American Gothic*, 1930
Oil on paperboard, 12⅝ x 14⅝ in.
National Museum of American Art, Smithsonian Institution
Gift of Park and Phyllis Rinard, 1991.122.2R

37 Photomacrograph of *American Gothic* (Plate 16) showing drawing lines and areas of exposed ground in the facade of the house

paintings. In other areas, the ground is completely covered by solid opaque paint. The woman's dress was painted first in dark brown, to which white details were added. A lighter brown was then applied over the dark brown and brushed carefully around many of the white spots and circles. Another style of paint application may be seen in the faces, where fine, fluid brush strokes partially cover the ground (Figure 40).

Between and over paint layers are clear coatings of oil or oil-resin mixtures.[9] It seems likely that these coatings have discolored somewhat over the years. Where the ground is not covered by opaque paint, it has a warm yellow color, due in part to a pigmented toning layer and in part to an unpigmented,

transparent yellow layer. Much of the yellow tone in the man's overalls, for example, seems to be the result of discoloration of the transparent layer over the exposed ground. With the stereomicroscope, it is clear that in this area the opaque paint of the design lies over the transparent layer. In some areas, the use of unpigmented layers appears to have left a rather medium-rich surface, over which subsequent layers of paint did not wet well. An example may be seen in the man's eyebrow, where a black brush stroke of paint has broken into small dots (Figure 41). Pigmented glazes are also present, although in this painting it is somewhat difficult to characterize the degree of pigmentation. In the sky, an uneven, stippled gray-and-yellow coating is visible over the

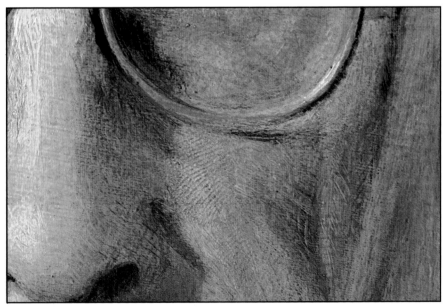

39 Photomacrograph of *American Gothic* (Plate 16) showing areas of exposed ground in the man's overalls

40 Photomacrograph of *American Gothic* (Plate 16) showing detail of the man's cheek and nose. Note the fingerprint at center.

opaque blue paint. It is interesting to note that this coating extends not *over* the blue paint used to cover the original chimney but *under* it (Figure 42), suggesting that the coating was applied by the artist and has discolored with time, darkening the original paint with it. In a 1942 photograph showing the subjects standing in front of the painting, the contrast between the original and repainted areas of the sky is already apparent. Since the pigmentation of this uneven gray-and-yellow layer has not yet been confirmed, the original appearance of this area remains somewhat uncertain. Analysis of the ground layer revealed a barium-zinc base (probably lithopone). Pigments present include zinc white, vermilion, iron oxides, red lake, chrome yellow, cadmium yellow, viridian, ultramarine blue, cobalt blue, and charcoal or ivory black.[10]

It is clear from the study of *American Gothic* that the construction of Wood's paintings is complex and calculated; the materials were manipulated to conform to the artist's conception of the finished painting. The following broader survey of materials from a number of Wood's paintings reveals a continuation of this approach during the 1930s.

Supports

At the beginning of the decade, Wood was still using inexpensive layered pulpboard, as in *American Gothic*, or Upson board, as in *Arnold Comes of Age* (Plate 23).[11] *Stone City, Iowa* (Plate 13) is painted on plywood, and the surface of the painting shows the fine cracks often present in veneer of this material.

41 Photomacrograph of *American Gothic* (Plate 16) showing detail of the man's eyebrow with beading of black paint

42 Photomacrograph of *American Gothic* (Plate 16) showing detail of the artist's overpainting in the chimney. Note that the stippled, discolored coating extends under the reworked area.

However, Wood soon began to use Masonite for both oil sketches and finished paintings, usually working on the smooth side.[12] As Masonite was developed in 1926,[13] Wood may have been one of the first artists to use it. For some paintings, fabric was adhered to a solid support. In *New Road* (Plate 10), a layer of double tabby-weave cotton canvas was glued with an unidentified adhesive to the smooth side of a Masonite panel. In *Haying* (Plate 9), a similar canvas was adhered to two layers of pulpboard, which were in turn adhered to the smooth side of a Masonite panel. In both cases, lamination of materials appears to have been done by the artist before application of the paint. *Parson Weems' Fable* (Plate 12) is painted on a lightweight tabby-weave linen fabric that was originally adhered with lead white to a Masonite panel.[14] Wood's preference for rigid supports may relate to the convenience of drawing, painting details, and applying glazes on a nonflexible support.

Grounds

The grounds of this period are usually white and, in some cases, appear to have been toned with a thin layer of paint not easily distinguishable from later glazes and coatings. In *American Gothic* (Plate 16), a warm tone is visible over the ground, while in *Arnold Comes of Age* (Plate 23), the tone is a thin gray layer. The grounds covering the solid supports are applied by brush in fluid, sweeping strokes that often overlap the edges slightly, indicating that the panels were trimmed to size before application. In some paintings, such as *Portrait of Nan* (Plate 1) and *American Gothic* (Plate 16), the brush marks follow a random curving pattern. In others, such as the study for *Stone City, Iowa* (Figure 10) and *Iowa Cornfield* (Plate 3), the pattern is more horizontal. The horizontal pattern of the ground in *Self Portrait* (Plate 22) may be seen clearly in

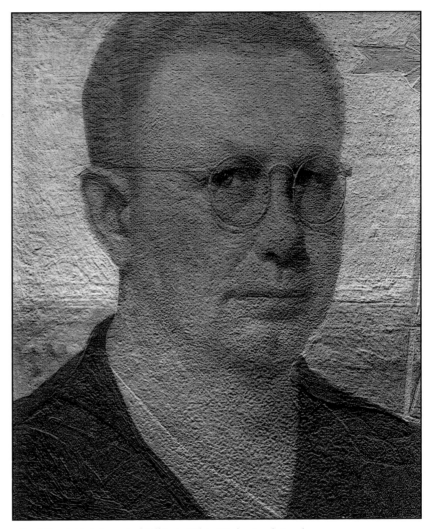

43　Raking light photograph of *Self Portrait* (Plate 22) showing design changes, grooved lines of unevenly applied ground, and texture of paint

the raking light photograph (Figure 43). In some of the paintings, such as *Daughters of Revolution* (Plate 15) and *Dinner for Threshers* (Plate 11), the ground is thinner and smoother. In *Stone City, Iowa,* the thin ground appears to have been scraped or sanded and the resulting exposed edges of the plywood support are covered with paint from the design layer.

Wood's assistant, Arnold Pyle, mentioned that the artist often used "several coats of [Benjamin] Moore's White Undercoat, an oil-base paint, instead of a gesso ground" to coat his panels.[15] Lee Allen, who knew Wood from 1939 and worked with him on the Ames murals (see below), also recalled that Wood used a commercial white paint for the ground layer. After the paint was allowed to settle in the can for a period of time, excess oil was poured off and Wood applied the remaining thick white paint to the panel.[16] Ground samples from several of these paintings were found to contain a barium-zinc white base in an oil medium with additions of chalk and quartz, a formulation not inconsistent with commercial paint.[17] The absence of lead white in the ground explains the lack of overall density in x-radiographs, as seen in *Self Portrait.* In contrast to the panels, the paintings on canvas have thin white primings.

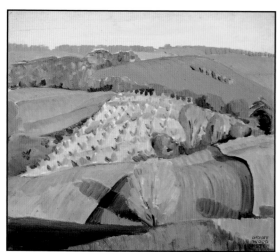

44 Study for *Fall Plowing,* 1931
Oil on Masonite panel, 13 x 15 in.
Davenport Museum of Art, 65.5

The priming of *Parson Weems' Fable* (Plate 12) contains zinc white and chalk in oil. The priming of *The Spotted Man* (Plate 8) contains lead white, while that of the Corn Room murals contains lead white with barium-zinc white and chalk.[18] In *Parson Weems' Fable,* the ground on the tacking margin of the canvas appears to have been commercially applied, but the same cannot be said with certainty for *Haying* and *New Road.*

Preparation and Drawings

The controlled rendering in Grant Wood's mature paintings was achieved through careful, systematic preparation. The artist often made preliminary oil sketches from nature, followed by drawings in pencil, chalk, or charcoal on heavy brown paper. At each stage, Wood edited and simplified the design so that the compositional elements were precisely placed and all extraneous information eliminated. In a 1940 article in a Los Angeles newspaper, he was quoted as saying:

> The public does not realize, perhaps, the amount of work that
> goes into one painting before I begin to set it down on canvas.
> In my last picture, I spent two months—fourteen hours a day,
> including Sundays—sketching, making notes, rejecting ideas.
> Because I paint so few pictures, I must necessarily be highly
> selective before I start to work.[19]

In *Fall Plowing* (Figure 44, Plate 35), the differences in composition between the oil sketch and the finished painting are not dramatic; the larger trees have been rearranged and a plow has been added in the foreground, with

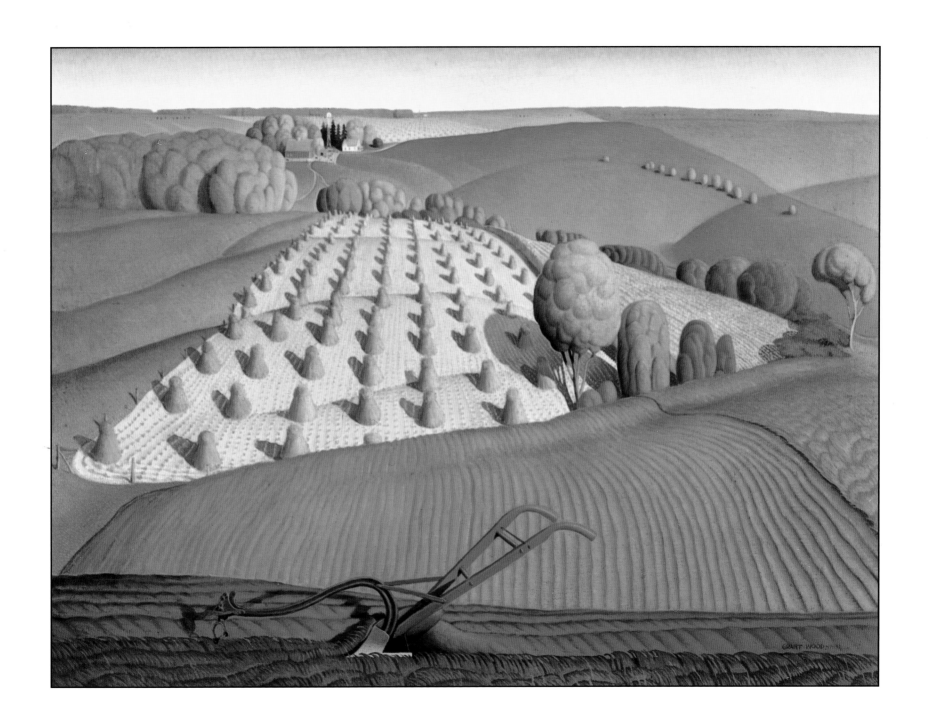

Plate 35
Fall Plowing, 1931
Oil on canvas, 30 x 40¾ in.
John Deere Art Collection

the same view recognizable in both paintings. In *Stone City, Iowa* (Plate 13), however, the tight control in the finished painting is much more striking. The painterly shapes of the trees in the sketch, outlined by scratched lines, have been replaced by perfectly rounded forms, some with over-sized, exaggerated leaves, emphasizing perspective lines that accelerate away from the viewer. Wood's use of oil sketches continued until the end of his life, as evidenced by the painting titled *Iowa Cornfield* (Plate 3), dated 1941. This composition shows lively brushwork in complementary colors reminiscent of earlier works. The crosshatching technique closely resembles that of lower design layers visible in later paintings, such as *Parson Weems' Fable* (Plate 12), with the aid of the infrared vidicon (Figure 45).

Wood began *American Gothic* (Plate 16) with a quick sketch of a farmhouse in Eldon, Iowa, then sent an assistant back to the site to take photographs.

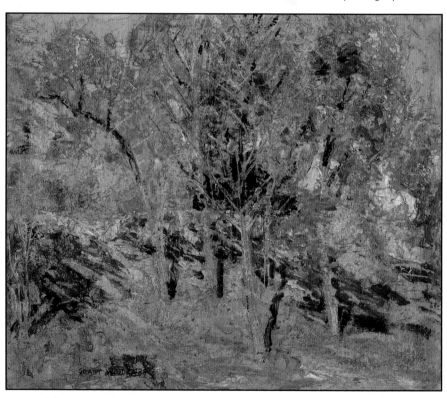

45 Infrared vidicon image of *Parson Weems' Fable* (Plate 12) showing loose crosshatching in the lower paint layers

46 Study for *Autumn Oaks*, 1928
Oil on composition board, 15 x 12¾ in.
Davenport Museum of Art
Gift of Mr. David L. Johnson, 78.117

Plate 36
Autumn Oaks, 1932
Oil on Masonite panel, 31 ½ x 37 ½ in.
Cedar Rapids Museum of Art
Cedar Rapids Community School District Collection, Iowa, 1970
Photograph courtesy French Studios, Cedar Rapids, Iowa

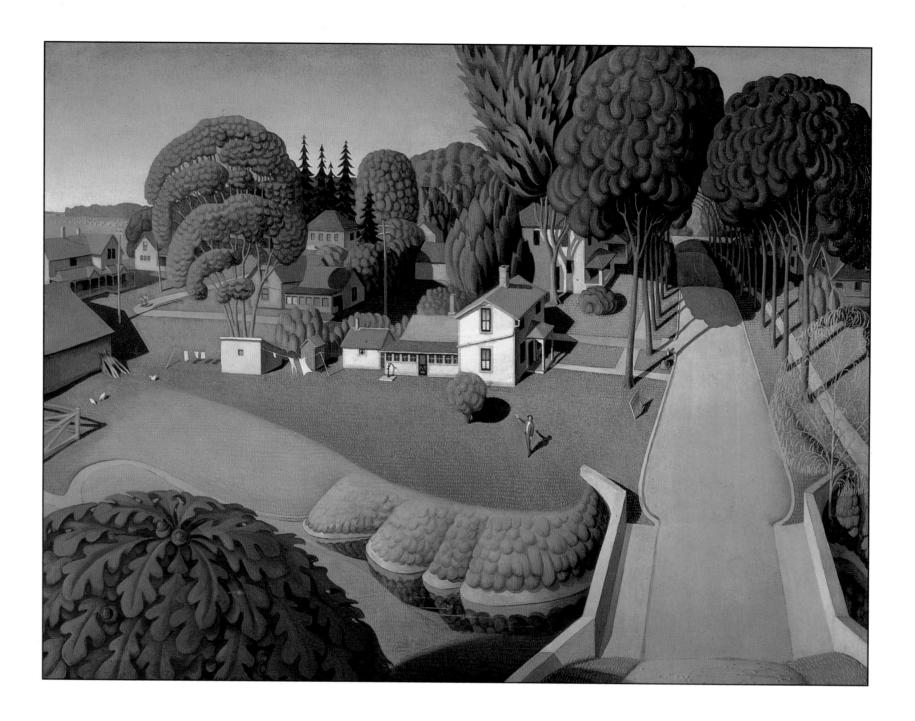

Plate 37
The Birthplace of Herbert Hoover, 1931
Oil on composition board, 29⅝ x 39¾ in.
Purchased jointly by the Des Moines Art Center and the Minneapolis Institute of Arts; purchased with funds from
Mrs. Howard H. Frank and the Edmundson Art Foundation, Inc., 1982.2

The oil sketch of 1930 is executed in the free, painterly style of the 1920s, with lively impasto and scratched highlights. As mentioned earlier, in the completed painting, drawing lines may be seen beneath the paint, over the heavy white ground. Other paintings, including *Arnold Comes of Age* (Plate 23) and *The Birthplace of Herbert Hoover* (Plate 37), also exhibit the same type of careful drawing lines over the ground, visible in areas not covered by paint. In the study for *Stone City, Iowa* (Figure 10), an underdrawing in red paint is present, while in the finished painting (Plate 13), small segments of red drawing lines are visible at the edges of the composition.

For many of Wood's later paintings, such as *Spring Turning* (Plate 4), *Parson Weems' Fable* (Plate 12), and *Spring in the Country* (1941, Cedar Rapids Museum of Art), full-scale cartoons in charcoal, pencil, and chalk were prepared. In the case of *Dinner for Threshers* (Plate 11), Wood made two chalk, pencil, and paint sketches, one for each end of the composition, before executing a full-scale, full-color preliminary drawing of the entire work.

47 Study for *The Birthplace of Herbert Hoover*, 1931
Charcoal, chalk, and graphite on tan paper, 29⅜ x 39⅜ in.
The University of Iowa Museum of Art
Gift of Edwin B. Green, 1985.92
Photograph © The University of Iowa Museum of Art
All rights reserved

The murals for the library at Iowa State University at Ames, painted in 1934 and 1935–1937, underwent an elaborate series of preparatory steps. After Wood executed a three-foot-square pilot color study in pencil, colored pencil, and chalk on paper, his principal assistant for this project, Francis McCray, created full-scale, eighteen-foot-square cartoons on brown paper. Wood insisted on historical accuracy for all elements and directed his assistants to carry out extensive research for the drawings. Large pieces of canvas, cut to fit into architectural spaces in the library, were washed repeatedly to remove creases, then sized and primed in preparation for painting. The designs were transferred to the canvases using a pouncing technique; holes were made in the paper along design lines and colored powder was forced through the holes onto the surface of the ground.

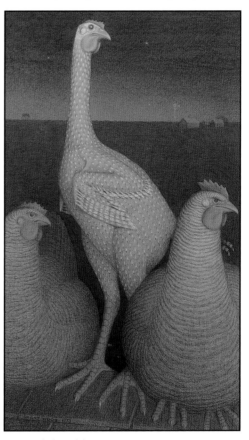

48 Study for *Adolescence*, 1933
Brush and black ink wash, pencil, and white chalk on brown paper, 24½ x 14⅝ in.
Collection of Richard and Leah Waitzer

After the pounced lines had been reinforced with pencil, painting was carried out by a team of assistants under Wood's supervision. The pouncing technique for transferring a preliminary drawing was used for other paintings as well.

Several of the paintings show raised or incised lines in parts of the design. In *Midnight Ride of Paul Revere* (Plate 2), narrow ridges or burrs of ground or paint, formed by drawing a sharp instrument along a straight edge, are

49 Photomacrograph of *Parson Weems' Fable* (Plate 12) showing detail of inscribed lines around the edges of the ball fringe

visible around the windows of the houses and in the church steeple. The x-radiograph confirms some of these ridges as sharp dark lines cut into the ground. Other, adjacent lines appear on the radiograph as sharp white lines, indicating that they are filled with brush strokes of denser paint. Dark lines also appear in the x-radiograph of *Dinner for Threshers* (Plate 11), following the architectural lines of the ceiling and walls, and in *Daughters of Revolution* (Plate 15), outlining the framed picture on the wall. In *Parson Weems' Fable* (Plate 12), inscribed lines are visible

around the windows, along the edge of the ladder, and around the tassel. In addition, perfectly circular inscribed lines are visible with the naked eye, and confirmed with the x-radiograph, around each of the circles of the ball fringe, suggesting the use of a compass or circular cutting tool (Figure 49). For some of the balls, more than one circle was inscribed but only one outline was followed in the final design; circular patterns of shrinkage crackle on the surface document the change. In *Dinner for Threshers* (Plate 11), the x-radiograph shows tiny dark dots at the centers of the wagon wheels such as might have been made with the registration point of a compass, but no circular inscribed lines are found.

For his precisely ordered "decorative" style of the 1930s, Wood drew not from the imagination but upon carefully observed and researched facts. In addition to working with illustrations or photographs, making extensive drawings, and conducting research on historical details, he also studied landscapes and buildings, consulted maps and atlases, and looked at quilts and folk paintings for ideas.[20] His penchant for mechanical aids drew criticism from those who claimed he relied on them too heavily and had no real talent as an artist. An experienced model maker, Wood built clay models of individual furrows in some landscapes to guarantee the accuracy and proportion of shadows. For *Breaking the Prairie* (Figure 50), one of the murals painted for Iowa State University at Ames in 1935–1937, he had a miniature model of the plow built and tested so that the furrows could be painted with historical accuracy.[21] For *Spring Turning* (Plate 4), he modeled the entire landscape in clay before beginning to paint.[22] For *Dinner for Threshers* (Plate 11), as with other paintings, he researched the shadows, determining exactly where they should lie according to the angle of declination

of the sun at that time of year.[23] He insisted that his students use his methods, teaching them to make drawings on brown paper[24] and to use Masonite panels of specific sizes.[25] Wood also developed a system of teaching design and perspective he called the principle of "thirds." He recommended dividing each edge of the paper or canvas into thirds, then placing every major compositional line along one of the diagonals formed by connecting these points (Figure 34).[26] In this way, the eye would always be carried back to the center of interest rather than out of the picture. Wood told a reporter in 1935: "I used to fight against the idea of mechanical devices in a painting . . . , but after I began teaching, I found that a simple device like this is of great help to beginners."[27]

Paint Application

For the most part, it appears that paint was applied without alteration of the composition as drawn, although some paintings contain passages in which the original drawing was modified by the application of paint. In these cases, the first paint layer was usually applied to conform to the drawing and subsequent layers were added to make changes. Many artists make design changes because of convenience in applying paint or expressiveness of the moment. Wood's paint application, however, resulted more from a deliberate attempt to adjust the drawing to improve the overall design.

With the development of Wood's mature style, his brush strokes generally became smaller and more uniform and were more carefully applied as they

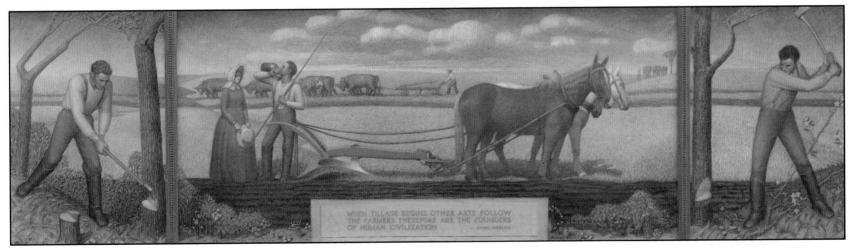

50 Study for *Breaking the Prairie*, 1935–1939
 Color pencil, chalk, and graphite on paper, triptych, overall 22¾ x 80¼ in.
 Whitney Museum of American Art
 Gift of Mr. and Mrs. George D. Stoddard, 81.33.2a–c
 Photograph copyright © 1995 Whitney Museum of American Art

described his subjects in increasingly meticulous detail. His finished paintings from this period often relied on the use of layer upon layer of small overlapped or crosshatched brush strokes to achieve the softly contoured, hard-edged forms of faces, buildings, trees, or rolling fields. However, he still incorporated passages of much broader brushwork in some areas. There are occasional indications that he used his fingers to aid in modeling; a distinct print is visible on the cheek of the man in *American Gothic* (Plate 16, Figure 40), and one eye in *Daughters of Revolution* (Plate 15) shows a similar mark. In juxtaposing small strokes of contrasting and complementary colors, Wood created a lively and luminous surface. Infrared examination of the paintings reveals that beneath the tightly controlled surfaces, the design was often laid in with much looser crosshatching. This is true even when a full-scale preparatory cartoon exists for the painting, as in *Parson Weems' Fable* (Plate 12, Figure 45) and *Dinner for Threshers* (Plate 11).

It appears that many of the paintings were developed broadly

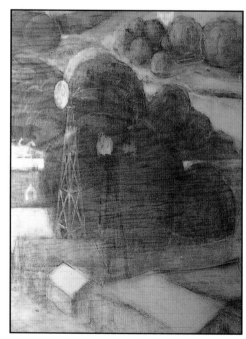

51 X-radiograph of *Stone City, Iowa* (Plate 13) showing the underlying design. Note placement of the primary windmill and an unidentified shape along the bottom, neither of which is visible in the finished painting.

in two stages. First, elements of the design were carefully laid in, following the drawing, as can be seen in instances in which drawing lines are visible. Background colors were brought up to, but not over, the edges of the forms, sometimes allowing narrow areas of ground to remain visible. Second, the image was evaluated and changes made to improve the overall design. X-radiographs of *The Birthplace of Herbert Hoover* (Plate 37) reveal that the initial layers of paint closely followed the drawing (Figure 47), which depicts a vignette of the original Hoover house at lower left (visible on the surface of the painting in specular light) as well as reflections of the main house in the stream at bottom center. These design elements are missing in the final composition. It is interesting to note that the radiograph also shows a side street and sidewalks along the right that are not present in either the drawing or the finished painting. In *Daughters of Revolution* (Plate 15), changes in the hand and teacup of the central figure are clearly documented in the x-radiograph, indicating that their original positioning was much closer to the preliminary drawing. Although no drawing is known to exist for *Haying* (Plate 9), examination with the infrared vidicon reveals that several changes were made during the execution of the painting, including replacement of a small barn in the upper right corner with a hay wagon.

In most of the paintings, the changes in the final composition are more minor. In *American Gothic* (Plate 16; see above), they may be seen with the unaided eye as well as in the x-radiograph. In *Stone City, Iowa* (Plate 13), the primary windmill has been shifted up and to the left and the fence lines at lower left have been altered. In addition, there is an unidentified shape along the bottom that is concealed by a field of small corn plants in the final design. As in *American Gothic*, these minor changes are visible in specular light and on the x-radiograph (Figure 51).

A dramatic example of reworking occurs in *Self Portrait* (Plate 22). In the charcoal sketch, the sitter is depicted in a white shirt and strapped overalls, Wood's typical mode of dress, with amorphous trees crowding behind his shoulders. In the painting, begun in 1932 and reworked in 1941, the artist is wearing a blue shirt and the background has been simplified into a series of repeating horizontal lines and diminutive cornstalks. An early stage of this painting is visible indistinctly in a 1932 photograph,[28] in which the head appears to be lighter than the surrounding background. The infrared reflectance photograph shows changes in the neckline, the tops of the shoulders, and the position of the upper part of the head. The image taken with the infrared vidicon confirms these changes but also reveals the presence of shoulder straps beneath the blue shirt. The x-radiograph (Figure 52)

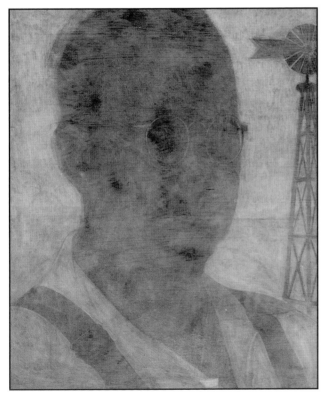

52 X-radiograph of *Self Portrait* (Plate 22) showing the underlying design, which is nearly identical to the charcoal sketch

reveals a design nearly identical to that of the sketch, with the sitter depicted in a light-colored shirt and overalls. As mentioned earlier, the lack of density in the face and along the straps indicates the absence of lead white in the ground. Raking light, from both the side and the top, proved to be almost as informative as infrared photography or x-radiography. Not only are the changes in the shirt, neck, and head clearly visible as raised or depressed lines in raking light but also the grooved lines of the unevenly applied ground and pointillist texture of the paint are apparent (Figure 43). At the left, near the horizon, the outline of what may have been an amorphous tree from an earlier design may be seen. In 1941, according to his sister, Nan, Wood reworked the painting, feeling that the overalls detracted from the face, but he was still unhappy with it at the end of his life. After Wood's death, Nan asked Marvin Cone, a close friend of Wood and fellow artist, to do "what he thought Grant would like to finish the painting."[29] Cone wrote to Nan in 1950:

> I have repainted *only* the little, somewhat triangular shapes on either side of the neck, *following very carefully the lines* originally used by Grant *also the colors*. These could be seen despite his scratching out of the area. The little haystacks on the left, I introduced because in the first painting (or underpainting) of which David Turner has a photograph, they appear. I am pleased with the result and hope it meets your approval.[30]

The presence of a blue glaze containing an acrylic resin[31] in the area of the shirt suggests that other additions have been made to the painting, possibly during conservation treatments.

The medium in Wood's paintings was found to be oil. In a few samples, there was an indication of resin admixed with the oil.[32] There was no evidence in the paintings sampled, however, of a protein binder. Arnold Pyle, Wood's assistant, emphatically denied that Wood ever used egg tempera for underpainting.[33] The multiple layers of oil paint are often separated by transparent, unpigmented layers and possibly pigmented glazes. Transparent layers were observed in samples from the Corn Room murals and *Arnold Comes of Age* (Plate 23), but identification of the coating was not possible. In *The Birthplace of Herbert Hoover* (Plate 37),

however, the interlayer coating was identified as a natural resin of the lac type,[34] which suggests that Wood may have used shellac to seal the ground or to isolate paint layers. A cross section (Figure 53) shows this clear, lac-type resin over a red drawing line and below the paint layer. A similar resin was also found in a green glaze layer in this painting. Lac-type resin samples were found in two other paintings as well, but because they were taken from residues located along the edges, they may not have been part of the original design. In *American Gothic* (Plate 16), an unidentified transparent layer with a pronounced yellow color, possibly a coating that has discolored since application, may be seen lying over areas of paint and

53 Photomicrograph of cross section of embedded paint from *The Birthplace of Herbert Hoover* (Plate 37) showing clear, lac-type resin over red drawing line and below paint layer (approximately 320x)

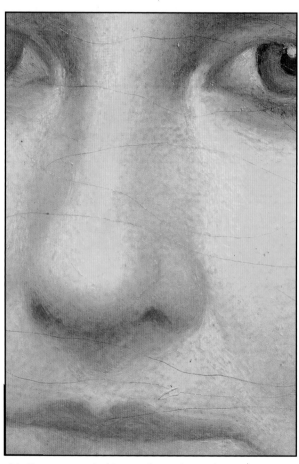

54 Photomacrograph of *Portrait of Nan* (Plate 1) showing detail of brush strokes and discolored coating in face

exposed ground (see above). In *Portrait of Nan* (Plate 1), a similar transparent yellow layer covers much of the painting and extends under some of the flesh tones in the face and red wall near the hands. In the face, the brush strokes that lie above the yellowed layer are noticeably lighter than the surrounding paint, suggesting that, as in *American Gothic,* discoloration of an artist-applied transparent coating has altered color relationships in this area (Figure 54).

Glazes were also used to tone, mute, or unify larger areas in paintings. Arnold Pyle recalled that Wood's "'glaze technique' consisted of 'wash glazes' with a single tint of color applied as a unifying tone over large areas of finished painting or over an entire work." The glaze was "lightly brushed onto the surface and then blotted with a rag before being sprayed with a retouch varnish as a drier in preparation for the next coat of glaze."[35] Lee Allen and William Bunn, two of Wood's colleagues, also recalled that in preparation for his glazing technique, the artist mixed equal parts of linseed oil, dammar varnish, and turpentine and added pigment from his tube paints. He then brushed this mixture over the entire surface of a well-dried painting until the image was almost totally obscured. After waiting several hours until the glaze had the right consistency, Wood used a lint-free cloth to wipe off the glaze until the desired effect was achieved. He then reworked details into the fresh glaze using tube colors. The technique described by Pyle, Allen, and Bunn could account for an unusual condition noted in several of the paintings. In *Midnight Ride of Paul Revere* (Plate 2), a stippled pattern of transparent, dark blue dots of varying sizes and densities may be seen throughout. At the edges of the painting, where a lower design is visible, a tide line or buildup of this color

has occurred, indicating general application of the glaze in this area. Examination under the binocular microscope suggests that multiple glaze layers are present; a cross section (Figure 55) shows several blue glaze layers with intervening clear coatings. In many of the paintings, landscape areas containing details such as grass or corn plants were toned with a brown glaze. The amount of pigmentation in the glaze appears to vary from one area to another, perhaps depending on the degree of modeling or unification desired (Figure 56). It is also possible that abrasion from previous cleanings has resulted in unevenness, which has become more noticeable as the coating darkens with age. In several paintings, glazes ranging

55 Photomicrograph of cross section of embedded paint from *Midnight Ride of Paul Revere* (Plate 2) showing layers of blue glaze and intervening clear coatings (approximately 320x)

in color from gray to green to brown may be seen in the sky. The stippled gray or brown noted in the sky and extending under reworked areas in *American Gothic* (Plate 16) provides an example.

Coatings

Because of the complex layering of paint and glazes, it was not always possible to determine whether a separate surface coating was present or to characterize it with certainty. In most cases, the uppermost layers of the paintings appear to be oil, natural resins of the tree or lac type, or mixtures of oil and resin.[36] Therefore, the question of whether or not Wood applied a final varnish coating to his paintings, in addition to the layers of

unpigmented glazes, cannot be answered without further study. In a few instances, a synthetic resin is present, suggesting a previous restoration.[37]

Alterations in the Paint Film

Many of the paintings show patterns of wrinkling and shrinkage crackle, ranging from mild cracks to severe alligatoring, which may be the result of excess medium, incompatible materials, or method of application. *Midnight Ride of Paul Revere* (Plate 2), *Daughters of Revolution* (Plate 15), *Parson Weems' Fable* (Plate 12), and *Haying* (Plate 9) all show patterns of tiny wrinkles in the paint associated with excess medium. Several areas of *American Gothic* (Plate 16) show beading of an upper, oil-rich paint layer over a rich lower layer (see above),

56 Photomacrograph of *The Birthplace of Herbert Hoover* (Plate 37) showing pigmented glaze in area of grass

57 Photomacrograph of *Sultry Night* (private collection) showing severe shrinkage crackle of paint, resulting in a pattern of dark dots over the underpainting

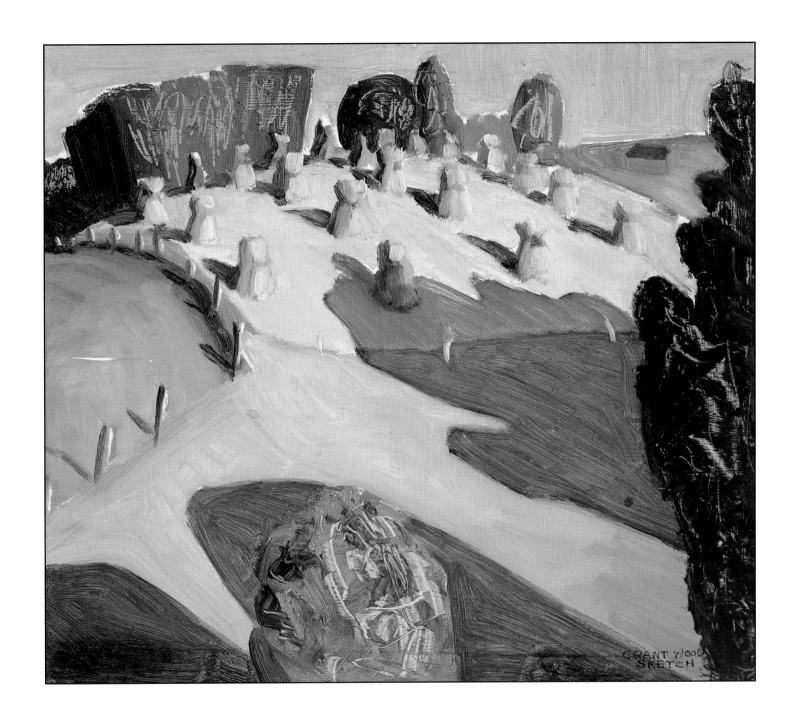

Plate 38
Iowa Landscape, 1941
Oil on Masonite panel, 13 x 15 in.
Davenport Museum of Art, 65.7

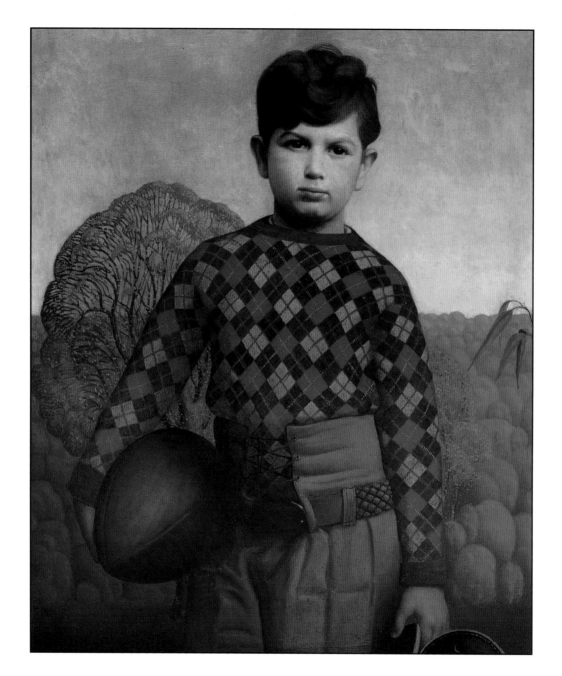

Plate 39
Plaid Sweater, 1931
Oil on Masonite panel, 29½ x 24⅛ in.
The University of Iowa Museum of Art
Gift of Melvin R. and Carole Blumberg and Edwin B. Green through the University of Iowa Foundation, 1984.56
Photograph © The University of Iowa Museum of Art

a phenomenon that probably occurred immediately after application and represents an integral part of the artist's construction. A dramatic example of shrinkage crackle revealing lower layers of paint (caused by stresses between slow-drying or incompatible layers) may be seen in the painting *Sultry Night* (Figure 57), in which shrinkage of the upper layer has resulted in a pattern of dark dots over the underpainting. In *Arnold Comes of Age* (Plate 23), shrinkage cracks in the upper paint layer have pulled apart the signature (Figure 58). The presence of natural resin-bound glazes and other materials mixed into the paint or applied between layers could have contributed to uneven drying. Wood's sister, Nan, reported that he used banana oil (presumably amyl acetate) in his paints and the odor filled the house for days, permeating the food.[38]

58 Photomacrograph of *Arnold Comes of Age* (Plate 23) showing shrinkage crackle in the signature

This slow-evaporating solvent could also have affected the drying of the layers. Wood frequently worked against deadlines and is known to have tried to hasten the drying process of *Woman with Plants* by placing the painting near a hot plate. When heat blisters formed, he carefully pushed them back into place with his finger.[39] As further evidence of Wood's hasty working methods, borders of texturally altered paint may be seen around the edges of many of his paintings, indicating that framing took place before the paint was completely dry. Despite problems of time and materials, the incompatibility of layers has not resulted in any chronic instability in the paint films, such as lifting or flaking of paint. Conservation records indicate, however, that several of the paintings have been extremely difficult to clean because of sensitivity of underlying paint layers to solvents.

Summary

Although both spontaneous and deliberate aspects may be seen in Grant Wood's early works, the style of his mature paintings of the 1930s shows increasingly greater calculation and more careful planning. The way in which he used his materials parallels the progression from loose, Impressionistic sketches with fluid brushwork to tighter, more refined compositions. Preliminary drawings, often accompanied by considerable research, assume greater importance in the preparation of finished paintings. Paint manipulation becomes more controlled and precise. Pigmented glazes and unpigmented coatings are applied locally or overall to achieve specific aesthetic effects. Masonite is used with greater frequency, perhaps because the more meticulous style lent itself to work on a rigid support. The particular working methods Wood used sometimes caused unplanned changes in the paint film, such as extreme shrinkage

crackle or discoloration of materials. Wood apparently maintained a lifelong interest in certain materials, such as the commercial white paint used for grounds, perhaps as a result of his early years as a decorator and craftsman.

Although this first technical study of Grant Wood's paintings offers better insight into many aspects of his mature work, it also raises many questions and reveals important differences among the individual paintings. It is clear that each painting must be evaluated separately while considering the artist's original intention and the painting's present condition. This study lays the groundwork for further investigation into the materials and working methods of this important American artist.

Acknowledgments

The authors would like to thank the following individuals for their generous help in preparing this essay: Lee Allen; Lynn Ambrosini, The Minneapolis Institute of Arts; M. Randall Ash, private conservator of paintings, Denver, Colorado; Leslie Blacksburg, Curator, Elvehjem Museum of Art, University of Wisconsin–Madison; Claire Barry, Chief Conservator of Paintings, Kimbell Art Museum, Fort Worth, Texas; Lucy Belloli, Conservator of Paintings, The Metropolitan Museum of Art, New York; John Bloom; Stephen D. Bonadies, Chief Conservator, Cincinnati Art Museum; William Bunn; Ernest Buresh and the Grant Wood Tourism Center, Anamosa, Iowa; Wanda M. Corn; Daphne Deeds, Sheldon Memorial Art Gallery, University of Nebraska–Lincoln; James M. Dennis; Lydia M. Dull, Photographer, Intermuseum Laboratory, Oberlin, Ohio; Inge Fiedler, The Art Institute of Chicago; Sarah L. Fisher, Head of Paintings Conservation, National Gallery of Art, Washington, D.C.; John Fitzpatrick, Cedar Rapids Community School District; Melanie Gifford, Research Conservator, National Gallery of Art, Washington, D.C.; E. Carl Grimm, Head of Paintings Conservation, The Fine Arts Museums of San Francisco; S. Ann Hoenigswald, Conservator of Paintings, National Gallery of Art, Washington, D.C.; Theodore James, Joslyn Art Museum, Omaha, Nebraska; Jay W. Krueger, Conservator of Modern Paintings, National Gallery of Art, Washington, D.C.; Timothy Lennon, Conservator of Paintings, The Art Institute of Chicago; Christopher McGlinchey, Research Chemist, The Metropolitan Museum of Art, New York; James S. Martin, Director of Analytical Services and Research, Williamstown Art Conservation Center; William J. Mulherin, Divisional Manager for Marketing Services, Benjamin Moore & Company; Jane Myers, Curator of Collections, Amon Carter Museum, Fort Worth, Texas; Patricia O'Regan, Assistant Paintings Conservator, M. H. de Young Memorial Museum, San Francisco; Park Rinard; Brady Roberts, Curator of Collections and Exhibitions, Davenport Museum of Art; Melissa G. Thompson, Registrar, Amon Carter Museum, Fort Worth, Texas; James A. Welu, Director, Worcester Art Museum; and Bonnie Wisniewski, Laboratory Technician, Painting Conservation, National Gallery of Art, Washington, D.C.

Notes

1. The paintings were examined with the unaided eye in normal, raking, and specular light, as appropriate, and with a binocular microscope. Invisible radiation, documented with ultraviolet fluorescence and infrared reflectance photography, as well as with x-radiography, was also used. Ultraviolet fluorescence provides information about surface features, such as varnish and recent restorations. Infrared radiation penetrates below the surface of a painting, often revealing drawings or changes made by the artist. X-radiography provides information about materials of different densities in the structure and makes it possible to distinguish between grounds containing lead white and those containing chalk.

2. A slotted painting carrying case measuring thirteen by fifteen inches, belonging to Grant Wood and now in the collection of the Davenport Museum of Art, may have been

used to transport panels painted in the 1920s, many of which fit these dimensions. In a painting of Indian Creek, flattened impasto indicates contact with other surfaces, possibly paintings in the studio or in a carrying case. Wood appears to have used some panels more than once. On the reverse of *Indian Creek* is a layer of bright red paint over which a sketch of the scene on the obverse has been hastily drawn in oil. When viewed in specular reflection, the reverse of *Truck Garden, Moret* (Plate 25), which has been completely overpainted in black, reveals the outline of a pair of shoes, perhaps a preliminary sketch for the painting *Old Shoes* done two years later.

3. See James S. Martin, "Technical Study of Materials Comprising Fourteen Paintings by Grant Wood" (Appendix A of this book).

4. Ibid.

5. Carl Eybers Jr., interview with Scott Sorensen, Sioux City, Iowa, March 20, 1979. Four known sets of Corn Room murals were painted for Eppley Hotels during this period, in the Iowa cities of Sioux City, Waterloo, Cedar Rapids, and Council Bluffs.

6. Photomicrographs are photographs taken with a compound microscope, at magnifications of approximately 25x to 1500x. Photomacrographs are photographs taken with a camera or a microscope without an ocular, at magnifications of 1x to 50x. Dan Kushel, "Photodocumentation for Conservation: Procedural Guidelines and Photographic Concepts and Techniques" (paper presented at the American Institute for Conservation Eighth Annual Meeting, San Francisco, Calif., May 1980), 23.

7. Martin, "Technical Study of Materials."

8. See Inge Fiedler, "A Study of the Materials Used in Grant Wood's *American Gothic*" (Appendix B of this book).

9. Martin, "Technical Study of Materials."

10. Fiedler, "Grant Wood's *American Gothic*."

11. The reverse of *Arnold Comes of Age* (Plate 23) is labeled "Upson Board." This material is a three-eighths-inch-thick pulpboard that is much softer than Masonite. Arnold Pyle was Wood's assistant for the majority of Wood's mature career.

12. *Iowa Cornfield* (Plate 3), Wood's last sketch, dated 1941, is painted on a hardboard panel that is slightly thicker (seven thirty-seconds of an inch) than the other panels and smooth on both sides. X-radiographs of this painting reveal a single screen pattern in the interior of the panel, not the double screen that might be expected had the panel consisted of two boards glued together. This support is probably S2S (smooth two sides) hardboard, first manufactured by U.S. Gypsum Company in 1938 under a license agreement with Masonite Corporation. Alexander W. Katlan, "Early Wood-Fiber Panels: Masonite, Hardboard, and Lower-Density Boards," *Journal of the American Institute for Conservation* 33 (fall–winter 1994), 304–5, and verbal communication, 1995.

13. Ibid., 304. While working as an interior decorator, Wood often used Masonite as a building material. For work on a house in Iowa City in 1935, he lined the kitchen with Masonite paneling that he grooved so that the boards could be joined unobtrusively. The Masonite Corporation liked Wood's idea and began producing grooved paneling shortly thereafter. Nan Wood Graham, *My Brother, Grant Wood* (Iowa City: State Historical Society of Iowa, 1993), 133.

14. The canvas was removed from the panel in 1974, when the painting underwent conservation treatment to correct surface deformations caused by uneven attachment to the Masonite. Physical evidence revealed during the conservator's examination suggested that Wood himself had attached the canvas to the panel. The reference to lead white is also based on the conservator's report and has not been confirmed by analysis.

15. James M. Dennis, *Grant Wood: A Study in American Art and Culture* (Columbia: University of Missouri Press, 1987), 238, and verbal communication, 1995.

16. Lee Allen, verbal communication, 1995.

17. Martin, "Technical Study of Materials." Fiedler's analysis of the ground in *American Gothic* identified a zinc-barium-sulfur mixture, probably a lithopone. Fiedler, "Grant Wood's *American Gothic*." (Positive identification of lithopone is not possible without powder x-ray diffraction. James S. Martin, verbal communication, 1995.) A 1924 formula for White Enamel Underbody, a primer manufactured by Benjamin Moore & Company and furnished to the authors by the company, describes a product containing a high percentage of lithopone with some magnesium silicate in a vehicle composed of treated drying oils, resins, and mineral spirits. William J. Mulherin, Benjamin Moore & Company, written communication, 1995. The results of analysis of the grounds lend strong support to Arnold Pyle's contention that Wood used a Benjamin Moore product.

18. Martin, "Technical Study of Materials."

19. Graham, *My Brother, Grant Wood*, 161–65.

20. Wanda M. Corn, *Grant Wood: The Regionalist Vision* (New Haven, Conn.: Yale University Press, 1983), 72–74.

21. Hazel E. Brown, *Grant Wood and Marvin Cone: Artists of an Era* (Ames: Iowa State University Press, 1972), 85.

22. Kate F. Jennings, *Grant Wood* (London: Bison Books, 1994), 91.

23. Graham, *My Brother, Grant Wood*, 114.

24. Corn, *Grant Wood*, 58.

25. Graham, *My Brother, Grant Wood*, 177.

26. Corn, *Grant Wood*, 58.

27. Graham, *My Brother, Grant Wood*, 122.

28. Corn, *Grant Wood*, 34; Plate 48.

29. Graham, *My Brother, Grant Wood*, 109.

30. Grant Wood Archives, Davenport Museum of Art. David Turner was an important patron of Grant Wood.

31. Martin, "Technical Study of Materials."

32. Ibid. Linseed oil cannot be distinguished from other drying oils by FT-IR (Fourier transform infrared microspectroscopy) alone. Chromatographic analysis of constituent fatty acids would be required to differentiate between oil binders. James S. Martin, verbal communication, 1995. (See Appendix A for further information on FT-IR.)

33. James M. Dennis, verbal communication, 1995, regarding earlier interview with Pyle.

34. Martin, "Technical Study of Materials."

35. Dennis, *Grant Wood*, 238.

36. Martin, "Technical Study of Materials."

37. The coating layer on samples from *Stone City, Iowa* was characterized by FT-IR as synthetic resin (acrylic). One coating layer from a sample from *The Birthplace of Herbert Hoover* was characterized by FT-IR as poly(vinylacetate), while another was characterized as a synthetic resin (acrylic). A synthetic resin (acrylic) was also identified in a sample of blue paint from the reworked shirt in *Self Portrait*. The coating layer on a sample from the Corn Room murals painted in 1925 was characterized by FT-IR as an alkyd resin. Ibid.

38. Graham, *My Brother, Grant Wood*, 11.

39. Ibid., 68.

APPENDIX A

TECHNICAL STUDY OF MATERIALS COMPRISING FOURTEEN PAINTINGS BY GRANT WOOD

BY JAMES S. MARTIN *Director of Analytical Services and Research, Williamstown Art Conservation Center*

In preparation for this exhibition and catalog, materials comprising fourteen paintings by Grant Wood were studied. The purpose of the study was to provide conservators Helen Mar Parkin and James S. Horns with a systematic survey of the types of materials used by Wood during his painting career. The paintings studied range in date of execution from 1924 to 1941 and are believed to be representative of Wood's oeuvre: *The Spotted Man* (1924), the Corn Room murals (c. 1925), *Indian Creek* (c. 1926), *Arnold Comes of Age* (1930), *American Gothic* (1930), Study for *Stone City* (1930), *Stone City, Iowa* (1930), *The Birthplace of Herbert Hoover* (1931), *Midnight Ride of Paul Revere* (1931), *Daughters of Revolution* (1932), *Self Portrait* (1932), *Dinner for Threshers* (1934), *Parson Weems' Fable* (1939), and *Iowa Cornfield* (1941).

The study involved analysis of minute samples of ground, paint, glaze, and coating layers provided by Horns and Parkin, Inge Fiedler (The Art Institute of Chicago), Christopher McGlinchey (The Metropolitan Museum of Art), and Patricia O'Regan (The Fine Arts Museums of San Francisco, M. H. de Young Memorial Museum). The samples were examined for interesting features, then divided for analysis by three standard microscopical techniques: polarized light and fluorescence microscopy (PLM/FM), scanning electron microscopy with energy-dispersive x-ray spectrometry (SEM-EDS), and Fourier transform infrared microspectroscopy (FT-IR).[1] This suite of analytical techniques permitted a survey of the layering and primary components of samples, thus equipping Parkin and

Horns to assemble a more complete profile of Wood's materials and techniques and laying the groundwork for further scientific investigations of Wood's materials. This appendix summarizes the results of the study. More information on procedures and results is available from the Williamstown Art Conservation Center.[2]

Cross-Sectional Analysis

Multilayered samples were examined in cross section to study the sequence in which various ground, underdrawing, paint, glaze, and coating layers were applied. So-called cross-sectional analysis provides a great deal of useful information regarding the number, sequence, thickness, condition, and interaction of these layers—characteristics that often are not clearly discernible at the surface of a painting. Cross-sectional analysis also helps the scientist isolate particular layers for analysis. Tables of cross-sectional analysis were prepared for each of the paintings analyzed but are too extensive for inclusion in this appendix. Table A1 condenses this information and summarizes the types of materials discussed here: grounds, underdrawing and interlayer coatings, paints and glazes, and surface coatings.

Grounds

Ground layers are applied to modify the absorbency and texture of the canvas or panel to which they are applied and are composed of pigments held

together with an organic binder (for example, lead white or zinc white in oil; chalk in animal glue). The ground in each of the fourteen paintings was analyzed. The binder in each of the ground samples is oil. The pigment in eleven of the ground samples is a barium-zinc white, sometimes with chalk and silicate materials added as extenders. This combination of pigments in oil appears to be consistent with anecdotal evidence that Wood used a commercial enamel underbody paint for his grounds called Moore's White Undercoat, a mixture of lithopone (a co-precipitated barium-zinc pigment), silicates, or chalk in oil with minor additions of resin and drier.[3]

Different pigments were found in the grounds of three paintings: lead white was found in *The Spotted Man,* lead white with barium-zinc white and chalk in the Corn Room murals,[4] and zinc white and chalk in *Parson Weems' Fable.*

Underdrawing and Interlayer Coatings

Painters sometimes use underdrawing to delineate design and composition over the ground. Underdrawing has been reported by Parkin and Horns on surface examination of Wood's paintings. Underdrawing was observed as a thin red stroke in a cross-sectional sample from *The Birthplace of Herbert Hoover.*

Varnishes are sometimes applied by painters to fix underdrawings and prepare previously applied paint for application of additional paint. The thin red underdrawing in *The Birthplace of Herbert Hoover* was covered with a coating layer characterized as a lac-type natural resin. Shellac is the most common type of lac resin. Lac-type natural resin was also found between paint layers on other samples from *The Birthplace of Herbert Hoover* and along the surface edges of *Arnold Comes of Age* and *Stone City, Iowa.* Coating layers were also observed between paint layers in samples from *American Gothic, Arnold Comes of Age,* the Corn Room murals, and *Midnight Ride of Paul Revere,* but these layers were not isolated for analysis.

Paints and Glazes

As with grounds, paints are composed of organic and inorganic pigments uniformly dispersed in a natural or synthetic binder. Natural paint binders include oils, proteins, natural resins, gums, and waxes. Both pigment and binder, as well as additives such as driers and wetting agents, can affect the way paint behaves in drying and aging. Very thin and translucent paints are commonly referred to as glazes.

Twenty-eight samples of paint from ten paintings were characterized for binder composition. Oil was clearly indicated in all but a few of the paint samples. No proteinaceous medium, such as glue, egg, or casein, was detected in any of the paint samples analyzed. Natural resins, gums, or waxes were not indicated as primary components of any of the original paint layers analyzed. A lac-type natural resin was used as the binder in a red glaze on *Stone City, Iowa* and in a green glaze on *The Birthplace of Herbert Hoover.* Owing to the great number of pigments used alone and in mixtures in the paint layers, individual pigments were not analyzed comprehensively. Among those pigments that were identified during binder analysis are ultramarine blue, Prussian blue, probable chrome yellow, yellow and red iron oxides, red lake, chalk, a cadmium-based pigment, and barium-zinc white, which was found alone as white and mixed with other pigments.[5] Lead white was not specifically detected in any of the paint samples analyzed.

Surface Coatings

Surface coatings, or varnishes, are commonly applied by painters to protect a painted surface and to increase its saturation and reflectance. Natural resins and mixtures of natural resin and oil were the most commonly applied surface coatings before the advent of synthetic resins in the middle part of this century. Oil coatings and other materials such as egg white, glue, and wax have also been used as surface coatings. As presentation surfaces, surface coatings are particularly prone to degradation, and their analysis can be easily complicated by previous cleaning, later application of varnish, or restoration. On analysis, surface coatings from the Wood paintings proved to be no exception.

Oil was clearly indicated on *Indian Creek* and *Dinner for Threshers,* while coatings on *American Gothic* and *Daughters of Revolution* appear also to contain natural resin. Natural resin coatings were found on *The Birthplace of Herbert Hoover, Midnight Ride of Paul Revere,* and *Iowa Cornfield.* A synthetic alkyd-type coating was found on the Corn Room murals, while other modern synthetic resins were found on *Arnold Comes of Age; Stone City, Iowa; The Birthplace of Herbert Hoover;* and *Midnight Ride of Paul Revere.*

Notes

1. For more information on PLM/FM and SEM-EDS, see E. Slayter and H. Slayter, *Light and Electron Microscopy* (Cambridge: Cambridge University Press, 1992). For more information on FT-IR and other analytical techniques applied to analysis of organic components of works of art, see J. Mills and R. White, *The Organic Chemistry of Works of Art* (Oxford: Butterworth-Heinemann, 1994).

2. Williamstown Art Conservation Center, 225 South Street, Williamstown, MA 01267.

3. Quantitative elemental analysis by electron microprobe of the ground sample from *American Gothic* provides confirmation that the barium-zinc pigment is a lithopone (see Appendix B).

4. Wood's use of different painting supports probably accounts for the observed differences in ground composition in *The Spotted Man* and the Corn Room murals.

5. See Appendix B for a more detailed analysis of pigments used in *American Gothic.*

TABLE A1. LAYER TYPES AND MATERIALS IN SELECTED PAINTINGS BY GRANT WOOD

This table compares the types of layers and materials found in samples from fourteen paintings by Grant Wood. Coatings and grounds from each painting were analyzed, but not all paint, glaze, and interlayer coatings were analyzed. Samples from some paintings contained only single layers, such as ground, paint, or coating; thus, information on other layers in these paintings is lacking. These results are not necessarily inclusive of all layers and materials present in the paintings, only of those layers in the samples provided that were analyzed. Additional analysis of samples may provide more conclusive data about specific binders and coatings and identify pigments and minor or trace components.

	The Spotted Man (1924)	Corn Room murals (c. 1925)	Indian Creek (c. 1926)	Arnold Comes of Age (1930)	American Gothic (1930)	Study for Stone City (1930)	Stone City, Iowa (1930)	The Birthplace of Herbert Hoover (1931)	Midnight Ride of Paul Revere (1931)	Daughters of Revolution (1932)	Self Portrait (1932)	Dinner for Threshers (1934)	Parson Weems' Fable (1939)	Iowa Cornfield (1941)
Grounds (Primary Pigment and Binder)														
Barium-zinc white in oil			■	■	■	■	■	■	■	■	■	■		■
Lead white in oil	■													
Lead white, barium-zinc white		■												
Zinc white in oil													■	
Underdrawing								■						
Interlayer Coatings														
Lac-type resin								■						
Oil or oil-resin mixture			■											
Present but not accessible		■		■	■				■					
Not present	■					■	■			■	■	■	■	■
Paints and Glazes (Binders in Selected Layers)														
Oil			■	■	■		■	■		■	■	■		
Natural resin, lac-type								■	■	■				
Synthetic											■			
Not conclusively analyzed		■				■								
Additional layers not analyzed		■	■	■	■	■	■	■		■	■	■		
Not present	■												■	■
Surface Coatings														
Natural resin								■	■					■
Natural resin, lac-type				■										
Oil			■									■		
Possible oil-resin mixture					■						■			
Synthetic		■		■			■		■					
Not present	■						■					■	■	

APPENDIX B
A STUDY OF THE MATERIALS USED IN
GRANT WOOD'S *AMERICAN GOTHIC*

BY INGE FIEDLER *Conservation Microscopist, The Art Institute of Chicago*

This appendix summarizes a preliminary investigation of the materials used in Grant Wood's painting *American Gothic*.[1] The purpose of sampling this work was to learn as much as possible about the materials the artist used and to gain some insight into his paint mixtures and technique. Included among the approximately forty samples were five cross sections used to study Wood's paint application and his technique of building up layers through the use of translucent and glaze materials.[2] Several samples were scrapings of surface material that, it was hoped, would answer questions about specific areas, particularly the grayish specks in the sky and the brownish spots on the woman's apron. Because sampling requires removal of material, it must be done selectively; thus, the minimum number of samples needed to adequately characterize the work was taken. Cross sections require the removal of considerably more material and, as such, were taken only from the edges of areas where paint loss had already occurred. A low-power stereomicroscope was used to aid in paint removal; the resulting samples were permanently mounted in a medium of known refractive index to aid in pigment identification. Typical sample size was on the order of a few milligrams. A polarized light microscope was used to identify the pigment material in each sample; this technique is used to analyze such optical and physical properties as color, shape, particle size, sample homogeneity, and complex optical phenomena of material.[3] In addition, several samples were analyzed by electron microprobe to provide confirmatory data.[4]

A summary of the materials that were identified from examination of *American Gothic* and some examples of the artist's pigment mixtures follow. It should be mentioned that Wood's paint mixtures were fairly complex, with the majority of samples containing at least five components.

Support

The artist used a composition board made from paper; identification of the paper fibers was not attempted. The Art Institute of Chicago's conservation files indicate that this work was painted on beaverboard. According to Ralph Mayer, this is a laminated board made from layers of paper waste and wood pulp that has a tendency to become brittle within a short time.[5]

Ground

The ground has been identified as a zinc-barium-sulfur mixture, probably a lithopone. Quantitative analysis of the ground performed by electron microprobe indicated a mixture typical of a lithopone with a 30 percent zinc sulfide and 70 percent barium sulfate ratio admixed with approximately 3 to 5 percent zinc oxide and minor to trace amounts of magnesium, silicon, aluminum, and calcium. Lithopones, co-precipitated pigments made of zinc sulfide and barium sulfate, have been used extensively in modern times as a primer for all types of surfaces. James M. Dennis has noted that Wood applied several coats of Moore's White Undercoat, an oil-based paint, to prime his boards.[6] The analysis of the ground material corresponds reasonably well to information supplied by Benjamin Moore & Company about its 1924 paint formulation.[7]

Whites

Zinc white (zinc oxide) was the principal white used in this work, both alone and in mixtures. It was identified in almost all of the samples taken, in quantities ranging from a few percent to approximately 95 percent. Quantitative analysis by electron microprobe of a sample of the man's white shirt indicated that it contained about 95 percent zinc oxide and 5 percent aluminum silicate. In addition to zinc white, minor to trace quantities of transparent, low-refractive-index whites were identified. These consisted of calcium carbonate, quartz, aluminum silicates, and possibly barium sulfate, compounds that are often used in paints as fillers or extenders.

Reds

The reds consisted of an iron oxide red, vermilion, and an unidentified red lake. Vermilion (mercuric sulfide) was used quite sparingly; only minor to trace amounts were identified in mixtures, such as those in the man's hand, in the grays, in the woman's orange-red cameo brooch, and in the light red highlight of the barn. Specific iron oxide reds, such as red ocher and Indian red, are very difficult to identify by analytical means because of similarities in composition; as such, they are referred to by their generic term. Iron oxide red was one of the main components, along with ultramarine blue, used for the reddish brown shadow of the man's finger. Vermilion and iron oxide red were often used together in mixtures with other pigments. An organic red lake, both as pale pink flakes and deeper pink particles, has been identified in mixtures from the shadow and highlights of the man's hand, the dark purple-gray curtain in the window of the house, the woman's orange-red cameo brooch, and one of the main components for the deep red leaf of the begonia plant. This pigment was not further characterized chemically.

Yellows

The yellows consisted of cadmium yellow (cadmium sulfide), chrome yellow (lead chromate), and iron oxide yellows. Cadmium yellow was used for the bright yellow highlight and also in mixtures with viridian to create various shades of yellow-green for the trees; it was also used in a number of other mixtures, such as for the highlight of the man's thumb. Presence of the elements cadmium and sulfur was confirmed by electron microprobe from a sample of the yellow-green highlight of a tree on the left of the painting. Two different shades of chrome yellow were identified by optical microscopy: a medium variety and a deeper yellow or orange type, possibly chrome orange. Medium chrome yellow was one of the main components in the light red highlight of the barn, and the deeper yellow-orange pigment was used for the orange cameo brooch. Wood used iron oxide yellow extensively in this work, especially in mixtures to paint translucent layers such as the upper grayish yellow-green layer of the man's jacket, the olive-greenish brown layer above the woman's black sleeve, and the yellow-brown layer applied over the trees. The latter consisted of a mixture of an organic material plus the following pigments: iron oxide yellow, possibly some chrome yellow, traces of vermilion or iron oxide red, and zinc white. As do iron oxide reds, the iron-based yellows also present a problem with exact identification.

Greens

The only green pigment identified in this painting was viridian, a hydrous chromium oxide. Viridian was mixed with cadmium yellow or chrome yellow

to create various shades of green for the trees, the leaves of the plants, and the green blinds above the door.

Blues

Ultramarine blue, a complex sodium aluminum sulfo-silicate, was the main blue detected. The man's jacket was painted primarily with ultramarine blue; it was also used in minor amounts for the overalls, in a mixture for the man's hand, in the black shadow of the woman's dress, and in trace amounts for the light blue sky. Small quantities of cobalt blue (cobalt aluminate) were used along with ultramarine blue and a high concentration of zinc white in the sky. Cobalt blue was also used in a mixture to paint the dark purple-gray curtain in the window and the man's blue-gray overalls.

Browns

The artist used various types of iron oxide browns and red-browns such as raw sienna, burnt sienna, and burnt umber; these were often combined with iron oxide yellows. As mentioned earlier, the exact types of iron oxide pigments are not easily identified. Some examples include the woman's brown apron, both for the lighter upper layer and mixed with an organic brown for the reddish brown transparent layer underneath. Iron-based browns and red-browns were also incorporated in the upper grayish yellow-green translucent layer as well as the blue underlayer of the man's jacket.

Blacks

Three different types of black were identified by optical microscopy. Possible lamp black was present in the underdrawing, much of which was intentionally left visible in this painting. The other two probable blacks were charcoal and bone or ivory black. These were used in amounts varying from a few percent in some samples to approximately 80 percent in the shadow of the woman's black dress.

Summary

This study, although incomplete, shows the complexity of Grant Wood's paint application and types of materials used. His palette was fairly extensive and consisted of a wide range of colors, combining traditional pigments such as the earth colors with more modern pigments such as lithopones, cadmium yellows, and viridian. More research needs to be conducted to ascertain the composition of the various iron compounds, red lakes, and carbon blacks as well as to identify the glazes and translucent layers. A comparison of materials from Wood's other paintings would contribute to a better understanding of the development of the artist's methods.

Notes

1. Grant Wood, *American Gothic*, painted in 1930; in the collection of The Art Institute of Chicago, 1930.934; Friends of American Art Collection.
2. See James S. Martin's summary of analysis of the cross sections in "Technical Study of Materials Comprising Fourteen Paintings by Grant Wood" (Appendix A of this book).
3. See Walter C. McCrone, Lucy B. McCrone, and John G. Delly, *Polarized Light Microscopy* (Ann Arbor, Mich.: Ann Arbor Science Publishers, 1978).
4. Electron microprobe analysis uses certain electron-induced x-rays to identify the chemical elements present in a few cubic micrometers of a sample. Six samples were analyzed using the electron microprobe at McCrone Associates, Westmont, Illinois.
5. Ralph Mayer, *The Artist's Handbook of Materials and Techniques*, 3rd ed. (New York: Viking Press, 1970), 264.
6. James M. Dennis, *Grant Wood: A Study in American Art and Culture* (New York: Viking Press, 1975), 239.
7. Based on information supplied by Benjamin Moore & Company to Helen Mar Parkin, July 6, 1995.

PLATE LIST

1. *Portrait of Nan*, 1933
 Oil on Masonite panel, 34½ x 28½ in. (oval)
 On loan to the Elvehjem Museum of Art,
 University of Wisconsin–Madison
 Collection of William Benton

2. *Midnight Ride of Paul Revere*, 1931
 Oil on composition board, 30 x 40 in.
 The Metropolitan Museum of Art
 Arthur Hoppock Hearn Fund, 50.117

3. *Iowa Cornfield*, 1941
 Oil on Masonite panel, 13 x 15 in.
 Davenport Museum of Art, 60.1013

4. *Spring Turning*, 1936
 Oil on Masonite panel, 18¼ x 40¼ in.
 Reynolda House Museum of American Art,
 Winston-Salem, North Carolina
 Gift of Barbara B. Millhouse

5. *The Little Chapel Chancelade*, 1926
 Oil on composition board, 13 x 16 in.
 Davenport Museum of Art, 65.6

6. *The Grand Cascade Bois de Bologne, Paris*, 1923
 Oil on composition board, 13 x 15 in.
 Collection of Rev. Francis A. Lana

7. *Oil Jar—Sorrento*, 1924
 Oil on composition board, 12 x 15 in.
 Collection of Dr. and Mrs. R. W. Lengeling

8. *The Spotted Man*, 1924
 Oil on canvas, 32 x 20 in.
 Davenport Museum of Art
 Fiftieth Anniversary Purchase, 75.14

9. *Haying*, 1939
 Oil on canvas adhered to paperboard
 mounted on hardboard, 12⅞ x 14⅞ in.
 National Gallery of Art, Washington
 Gift of Mr. and Mrs. Irwin Strasburger, 1982.7.1

10. *New Road*, 1939
 Oil on canvas adhered to paperboard
 mounted on hardboard, 13 x 14⅞ in.
 National Gallery of Art, Washington
 Gift of Mr. and Mrs. Irwin Strasburger, 1982.7.2

11. *Dinner for Threshers*, 1934
 Oil on hardboard, 20 x 80 in.
 The Fine Arts Museums of San Francisco
 Gift of Mr. and Mrs. John D. Rockefeller 3rd, 1979.7.105

12. *Parson Weems' Fable*, 1939
 Oil on canvas, 38⅜ x 50⅛ in.
 Amon Carter Museum, Fort Worth, Texas
 1970.43

13. *Stone City, Iowa*, 1930
 Oil on wood panel, 30¼ x 40 in.
 Joslyn Art Museum, Omaha, Nebraska
 Art Institute of Omaha Collection, 1930.35

14. *Appraisal*, 1931
 Oil on composition board, 29¼ x 35¼ in.
 Carnegie-Stout Public Library, Dubuque, Iowa

15. *Daughters of Revolution*, 1932
 Oil on Masonite panel, 20 x 40 in.
 Cincinnati Art Museum
 The Edwin and Virginia Irwin Memorial, 1959.46

16. *American Gothic*, 1930
 Oil on beaver board, 29⅞ x 24⅞ in.
 The Art Institute of Chicago
 Friends of American Art Collection, 1930.934

17. *Return from Bohemia*, 1935
 Crayon, gouache, and pencil on paper, 23½ x 20 in.
 The Regis Collection, Minneapolis, Minnesota

18. *Booster*, 1936
 Charcoal, pencil, and chalk on brown paper, 20½ x 16 in.
 Davenport Museum of Art
 Friends of Art Permanent Endowment Fund
 and a gift from Mr. and Mrs. Morris Geifman, 93.3

19. *Sentimental Yearner*, 1936
 Crayon, gouache, and pencil on paper, 20¼ x 16 in.
 The Minneapolis Institute of Arts
 Gift of Alan Goldstein, 80.91

20. *The Perfectionist*, 1936
 Crayon, gouache, charcoal, ink, and opaque watercolor
 on brown wove paper, 25⅝ x 20 in.
 The Fine Arts Museums of San Francisco
 Gift of Mr. and Mrs. John D. Rockefeller 3rd, 1979.7.106

21. *Return from Bohemia*, 1935
 Pastel on paper, 23¾ x 20 in.
 Collection of IBM Corporation, Armonk, New York

22. *Self Portrait*, 1932
 Oil on Masonite panel, 14¾ x 12⅜ in.
 Davenport Museum of Art, 65.1

23. *Arnold Comes of Age*, 1930
 Oil on board, 26¾ x 23 in.
 Sheldon Memorial Art Gallery, University of Nebraska–Lincoln
 Nebraska Art Association Collection, 1931.N-38

24. *Plowing*, 1936
 Charcoal, crayon, chalk, and pencil, 23½ x 29½ in.
 Private collection

25. *Truck Garden, Moret*, 1924
 Oil on composition board, 12½ x 15¾ in.
 Davenport Museum of Art, 65.3

26. *Mixed Bouquet on a Covered Table (Flowers for Alice)*, 1928
 Oil on canvas, 21½ x 22 in.
 On loan to Brucemore, Inc., Cedar Rapids, Iowa
 Private collection

27. *Mixed Bouquet in White Vase*, 1929
 Oil on Masonite panel, 20 x 22 in.
 Private collection

28. *Delphiniums in White Vase*, 1929
 Oil on canvas, 24 x 18¼ in.
 Private collection

29. *Zinnias*, 1930
Oil on composition board, 24 x 30 in.
Private collection

30. *Near Sundown*, 1933
Oil on canvas, 15 x 26½ in.
Spencer Museum of Art, The University of Kansas
Gift of Mr. George Cukor, 59.70

31. *Death on the Ridge Road*, 1935
Oil on Masonite panel, 32 x 39 in.
Williams College Museum of Art
Gift of Cole Porter, 47.1.3

32. *Four Seasons Lunettes: Summer*, c. 1922–1925
Oil on canvas mounted on board (arched frame), 16⅛ x 29⅛ in.
Cedar Rapids Community School District, Iowa

33. *Four Seasons Lunettes: Autumn*, c. 1922–1925
Oil on canvas mounted on board (arched frame), 16⅜ x 45⅝ in.
Cedar Rapids Community School District, Iowa

34. *Four Seasons Lunettes: Winter*, c. 1922–1925
Oil on canvas mounted on board (arched frame), 19½ x 39¼ in.
Cedar Rapids Community School District, Iowa

35. *Fall Plowing*, 1931
Oil on canvas, 30 x 40¾ in.
John Deere Art Collection

36. *Autumn Oaks*, 1932
Oil on Masonite panel, 31½ x 37½ in.
Cedar Rapids Museum of Art
Cedar Rapids Community School District Collection, Iowa, 1970

37. *The Birthplace of Herbert Hoover*, 193
Oil on composition board, 29⅝ x 39¾ in.
Purchased jointly by the Des Moines Art Center and the Minneapolis
Institute of Arts; purchased with funds from Mrs. Howard H. Frank and the
Edmundson Art Foundation, Inc., 1982.2

38. *Iowa Landscape*, 1941
Oil on Masonite panel, 13 x 15 in.
Davenport Museum of Art, 65.7

39. *Plaid Sweater*, 1931
Oil on Masonite panel, 29½ x 24⅛ in.
The University of Iowa Museum of Art
Gift of Melvin R. and Carole Blumberg and Edwin B. Green through the
University of Iowa Foundation, 1984.56

CHRONOLOGY

1891 February 13: Grant Wood is born on a farm near Anamosa, Iowa

1910 Graduates from high school and travels to Minneapolis to take a summer course taught by Ernest Batchelder at the School of Design and Handicraft

1911 Returns to Minneapolis for a second summer at the School of Design and Handicraft

1913–1916 Lives in Chicago, occasionally taking night classes at The Art Institute of Chicago

1913 Armory Show is presented in Chicago

1919–1925 Teaches in the Cedar Rapids, Iowa, public school system

1920 Summer: Travels to Paris for the first time, with Marvin Cone

1923–1924 Returns to Paris, studies at the Académie Julian, and travels to Sorrento, Italy. *The Spotted Man* (1924)

1926 Summer: Third trip to Paris culminates in an exhibition of thirty-seven paintings at the Galerie Carmine

1927 Awarded a commission to create a stained glass window for the Cedar Rapids Veterans Memorial Building

1928 Spends three months in Munich supervising production of a stained glass window. Visits Alte Pinakothek

1930 *Arnold Comes of Age; Stone City, Iowa; American Gothic*

1931 *The Birthplace of Herbert Hoover, Midnight Ride of Paul Revere, Appraisal, Fall Plowing*

1932 Summer: Stone City Colony and Art School operates for two consecutive summers, attracting midwestern art students. *Daughters of Revolution, Arbor Day, Self Portrait*

1934 Appointed director of Public Works of Art Project in Iowa and Associate Professor of Fine Arts at the University of Iowa. *Dinner for Threshers*

1935 Marries Sara Maxon and moves to Iowa City. *Death on the Ridge Road, Return from Bohemia*

1936 *Spring Turning*

1937 Creates illustrations for Sinclair Lewis's *Main Street*

1938 Separates from Sara Maxon

1939 Divorces Sara Maxon. *Parson Weems' Fable, Haying, New Road*

1942 February 12: Dies of cancer

EXHIBITION CHECKLIST

1. *Four Seasons Lunettes*, c. 1922–1925
 Oil on canvas mounted on board (arched frames)
 (a) *Spring*, 19 ½ x 39 ¼ in.
 (b) *Summer*, 16 ⅛ x 29 ⅛ in.
 (c) *Autumn*, 16 ⅜ x 45 ⅝ in.
 (d) *Winter*, 19 ½ x 39 ¼ in.
 Cedar Rapids Community School District, Iowa

2. *The Grand Cascade Bois de Bologne, Paris*, 1923
 Oil on composition board, 13 x 15 in.
 Collection of Rev. Francis A. Lana

3. *Bridge at Moret,* 1924
 Oil on composition board, 12 ¾ x 16 in.
 Cedar Rapids Community School District, Iowa

4. *Oil Jar—Sorrento*, 1924
 Oil on composition board, 12 x 15 in.
 Collection of Dr. and Mrs. R. W. Lengeling

5. *The Spotted Man*, 1924
 Oil on canvas, 32 x 20 in.
 Davenport Museum of Art
 Fiftieth Anniversary Purchase, 75.14

6. *Truck Garden, Moret*, 1924
 Oil on composition board, 12 ½ x 15 ¾ in.
 Davenport Museum of Art, 65.3

7. *The Little Chapel Chancelade*, 1926
 Oil on composition board, 13 x 16 in.
 Davenport Museum of Art, 65.6

8. *Indian Creek,* c. 1926
 Oil on composition board, 13 ¹⁄₁₆ x 14 ⅞ in.
 Private collection

9. *Mixed Bouquet on a Covered Table (Flowers for Alice)*, 1928
 Oil on canvas, 21 ½ x 22 in.
 On loan to Brucemore, Inc., Cedar Rapids, Iowa
 Private collection

10. Study for *Autumn Oaks*, 1928
 Oil on composition board, 15 x 12 ¾ in.
 Davenport Museum of Art
 Gift of Mr. David L. Johnson, 78.117

11. *Sunlit House*, 1928
 Oil on composition board, 13 x 15 in.
 Davenport Museum of Art, 1995

12. *Delphiniums in White Vase*, 1929
 Oil on canvas, 24 x 18 ¼ in.
 Private collection

13. Study for house in *American Gothic*, 1930
 Oil on paperboard, 12 ⅝ x 14 ⅝ in.
 National Museum of American Art, Smithsonian Institution
 Gift of Park and Phyllis Rinard, 1991.122.2R

14. *American Gothic*, 1930
 Oil on beaver board, 29 ⅞ x 24 ⅞ in.
 The Art Institute of Chicago
 Friends of American Art Collection, 1930.934

15. *Arnold Comes of Age*, 1930
 Oil on board, 26¾ x 23 in.
 Sheldon Memorial Art Gallery, University of Nebraska–Lincoln
 Nebraska Art Association Collection, 1931.N-38

16. Study for *Stone City*, 1930
 Oil on Masonite panel, 13 x 15 in.
 Davenport Museum of Art, 65.4

17. *Stone City, Iowa*, 1930
 Oil on wood panel, 30¼ x 40 in.
 Joslyn Art Museum, Omaha, Nebraska
 Art Institute of Omaha Collection, 1930.35

18. *Zinnias*, 1930
 Oil on composition board, 24 x 30 in.
 Private collection

19. *Appraisal*, 1931
 Oil on composition board, 29½ x 35¼ in.
 Carnegie-Stout Public Library, Dubuque, Iowa

20. Study for *The Birthplace of Herbert Hoover*, 1931
 Charcoal, chalk, and graphite on tan paper, 29⅜ x 39⅜ in.
 The University of Iowa Museum of Art
 Gift of Edwin B. Green, 1985.92

21. *The Birthplace of Herbert Hoover*, 1931
 Oil on composition board, 29⅝ x 39¾ in.
 Purchased jointly by the Des Moines Art Center and the Minneapolis
 Institute of Arts; purchased with funds from Mrs. Howard H. Frank and the
 Edmundson Art Foundation, Inc., 1982.2

22. Study for *Fall Plowing*, 1931
 Oil on Masonite panel, 13 x 15 in.
 Davenport Museum of Art, 65.5

23. *Fall Plowing*, 1931
 Oil on canvas, 30 x 40¾ in.
 John Deere Art Collection

24. *Midnight Ride of Paul Revere*, 1931
 Oil on composition board, 30 x 40 in.
 The Metropolitan Museum of Art
 Arthur Hoppock Hearn Fund, 50.117

25. *Plaid Sweater*, 1931
 Oil on Masonite panel, 29½ x 24⅛ in.
 The University of Iowa Museum of Art
 Gift of Melvin R. and Carole Blumberg and
 Edwin B. Green through the
 University of Iowa Foundation, 1984.56

26. *Autumn Oaks*, 1932
 Oil on Masonite panel, 31½ x 37½ in.
 Cedar Rapids Museum of Art
 Cedar Rapids Community School District Collection, Iowa, 1970

27. Study for *Daughters of Revolution*, 1932
 Pencil, charcoal, and chalk on paper, 22 x 41¾ in.
 Coe College Permanent Collection of Art, Cedar Rapids, Iowa

28. *Daughters of Revolution*, 1932
 Oil on Masonite panel, 20 x 40 in.
 Cincinnati Art Museum
 The Edwin and Virginia Irwin Memorial, 1959.46

29. Study for *Self Portrait*, 1932
Charcoal and pastel on paper, 14½ x 12 in.
Cedar Rapids Museum of Art
Art Association Purchase, 93.11

30. *Self Portrait*, 1932
Oil on Masonite panel, 14¾ x 12⅜ in.
Davenport Museum of Art, 65.1

31. *History of Penmanship: Stylus and Wax Tablet of the Greeks,* 1933
Charcoal on paper, 30¾ x 42 in.
Davenport Museum of Art, 65.12

32. *Near Sundown*, 1933
Oil on canvas, 15 x 26½ in.
Spencer Museum of Art, The University of Kansas
Gift of Mr. George Cukor, 59.70

33. *Portrait of Nan*, 1933
Oil on Masonite panel, 34½ x 28½ in. (oval)
On loan to the Elvehjem Museum of Art,
University of Wisconsin–Madison
Collection of William Benton

34. Study for *Adolescence*, 1933
Brush and black ink wash, pencil, and white chalk
on brown paper, 24½ x 14⅝ in.
Collection of Richard and Leah Waitzer

35. Study for *Dinner for Threshers*, 1934
Pencil on paper, 18 x 72 in.
Private collection

36. *Dinner for Threshers*, 1934
Oil on hardboard, 20 x 80 in.
The Fine Arts Museums of San Francisco
Gift of Mr. and Mrs. John D. Rockefeller 3rd, 1979.7.105

37. Study for *Death on the Ridge Road*, 1934
Pencil and chalk on paper, 31¼ x 39 in.
Private collection

38. *Death on the Ridge Road*, 1935
Oil on Masonite panel, 32 x 39 in.
Williams College Museum of Art
Gift of Cole Porter, 47.1.3

39. *Return from Bohemia*, 1935
Crayon, gouache, and pencil on paper, 23½ x 20 in.
The Regis Collection, Minneapolis, Minnesota

40. Study for *Breaking the Prairie*, 1935–1939
Color pencil, chalk, and graphite on paper,
triptych, overall 22¾ x 80¼ in.
Whitney Museum of American Art
Gift of Mr. and Mrs. George D. Stoddard, 81.33.2a–c

41. *Booster*, 1936
Charcoal, pencil, and chalk on brown paper, 20½ x 16 in.
Davenport Museum of Art
Friends of Art Permanent Endowment Fund
and a gift from Mr. and Mrs. Morris Geifman, 93.3

42. *The Perfectionist*, 1936
Crayon, gouache, charcoal, ink, and
opaque watercolor on brown wove paper, 25 ⅝ x 20 in.
The Fine Arts Museums of San Francisco
Gift of Mr. and Mrs. John D. Rockefeller 3rd, 1979.7.106

43. *Sentimental Yearner*, 1936
Crayon, gouache, and pencil on paper, 20 ¼ x 16 in.
The Minneapolis Institute of Arts
Gift of Alan Goldstein, 80.91

44. *Spring Turning*, 1936
Oil on Masonite panel, 18 ¼ x 40 ¼ in.
Reynolda House Museum of American Art,
Winston-Salem, North Carolina
Gift of Barbara B. Millhouse

45. *The Good Influence*, 1936–1937
Black carbon pencil, india ink, and white gouache on
tan wove paper, 20 ½ x 16 ¼ in.
Pennsylvania Academy of the Fine Arts, Philadelphia
Collections Fund, 1952.6.2

46. *Fertility*, 1937
Lithograph on paper, 9 ⅜ x 12 ¼ in.
Davenport Museum of Art, 65.31

47. *Honorary Degree*, 1937
Lithograph on paper, 12 ⅜ x 7 ¼ in.
Davenport Museum of Art, 65.35

48. *Honorary Degree*, c. 1937 (dated 1939)
Ink, charcoal, and pencil on board, 12 x 7 in.
The FORBES Magazine Collection, New York

49. *January*, 1937
Lithograph on paper, 9 ⅜ x 12 ¼ in.
Davenport Museum of Art, 65.26

50. *Main Street,* by Sinclair Lewis
Limited edition, Lakeside Press, Chicago, 1937
Illustrated by Grant Wood
Collection of George and Janelle McClain

51. *Tree Planting Group*, 1937
Lithograph on paper, 9 x 11 ¼ in.
Davenport Museum of Art
Gift of the Friends of Art, 75.22

52. *Village Slums*, 1937
Charcoal, pencil, and chalk on paperboard
mounted on foam core, 26 ⅝ x 21 ⅛ in.
National Museum of American Art, Smithsonian Institution
Gift of Park and Phyllis Rinard, 1991.122.1

53. *January*, 1938
Charcoal, pencil, and chalk on paper, 20 ½ x 26 ½ in.
Private collection

54. *Family Saying Grace*, c. 1938
Pencil on paper, 36 x 42 in.
Davenport Museum of Art, 65.16

55. *Haying*, 1939
Oil on canvas adhered to paperboard
mounted on hardboard, 12 ⅞ x 14 ⅞ in.
National Gallery of Art, Washington
Gift of Mr. and Mrs. Irwin Strasburger, 1982.7.1

56. *July Fifteenth,* 1939
 Lithograph on paper, 9 ⅜ x 12 ¼ in.
 Davenport Museum of Art, 65.30

57. *New Road,* 1939
 Oil on canvas adhered to paperboard
 mounted on hardboard, 13 x 14 ⅞ in.
 National Gallery of Art, Washington
 Gift of Mr. and Mrs. Irwin Strasburger, 1982.7.2

58. Study for *Parson Weems' Fable,* 1939
 Charcoal, pencil, and chalk on paper, 38 ¼ x 50 in.
 Private collection

59. *Iowa Cornfield,* 1941
 Oil on Masonite panel, 13 x 15 in.
 Davenport Museum of Art, 60.1013

60. *Iowa Landscape,* 1941
 Oil on Masonite panel, 13 x 15 in.
 Davenport Museum of Art, 65.7

61. *March,* 1941
 Charcoal and white chalk on paper, 9 x 12 in.
 Davenport Museum of Art
 Gift of Nan Wood Graham, 60.1014

62. *March,* 1941
 Lithograph on paper, 9 ⅜ x 12 ¼ in.
 Davenport Museum of Art, 65.28

Note: Not every work in the exhibition traveled to each venue.

THE AUTHORS

JAMES M. DENNIS, Professor of Art History at the University of Wisconsin–Madison, has written extensively on the work of Grant Wood. His publications include the award-winning book *Grant Wood: A Study in American Art and Culture* (The Viking Press, 1975; University of Missouri Press, 1987). A nearly completed book, from which the present essay is derived, approaches Wood, Thomas Hart Benton, and John Steuart Curry as independent artists unencumbered by Regionalism or any other movement.

JAMES S. HORNS studied with Richard Buck at the Intermuseum Conservation Association at Oberlin College from 1971 to 1974, where he received a master's degree in conservation. He was Painting Conservator at the Minneapolis Institute of Arts from 1974 to 1978 and at the Upper Midwest Conservation Association from 1978 to 1986. Since that time, he has been a conservator in private practice in Minneapolis.

HELEN MAR PARKIN is a conservator of paintings in private practice in the Cincinnati area. She received a bachelor's degree in art history from Mount Holyoke College in 1969, a master's degree in museology from George Washington University in 1971, and a master's degree and certificate of advanced study in paintings from Conservation of Historic and Artistic Works, Cooperstown Graduate Programs, State University of New York at Oneonta, in 1974. She has worked as a conservator at the Worcester Art Museum, as an Andrew W. Mellon Fellow for Advanced Study in Painting Conservation at the Kimbell Art Museum, with Perry Huston and Associates, and at the Intermuseum Laboratory, where she was Head Paintings Conservator before entering private practice in 1990. She is a Fellow of the American Institute for Conservation (AIC) and an Associate Member of the International Institute for Conservation (IIC).

BRADY M. ROBERTS received his master's degree in art history from the University of Wisconsin–Madison in 1989, where he studied with James M. Dennis. He received his bachelor's degree in art history from the University of Illinois, Champaign-Urbana, and studied art history in Vienna. He has organized several nationally touring exhibitions for the Davenport Museum of Art, where he has been Curator of Collections and Exhibitions since 1989.

INDEX

Boldfaced page numbers indicate plates and figures. Works by artists other than Grant Wood are listed under the artists' names.

A

abstract art, 43
Académie Julian, 2, 15, 68
Adolescence (study), **79**
Adoration of the Home, 67
Allen, Lee, 74, 85
Alte Pinakothek, 19, 36
American Gothic, 15, 27, **28**, 39, 42 n. 38, 46; methods and materials used in, 69–72, 73, 76, 82, 84–85, 86, 92, 93, 94, 95, 96–98; photomacrograph of, showing areas of exposed ground in overalls, **71**; photomacrograph of, showing detail of artist's overpainting in chimney, **72**; photomacrograph of, showing detail of man's cheek and nose, **71**; photomacrograph of, showing detail of man's eyebrow, **72**; photomacrograph of, showing drawing lines, **70**
American Gothic (study), **70**
American modernism, 43, 46–48, 55
American Scene painters, 32
Ames murals, 74, 79–80
Antique painting, 3, 6
Appraisal, 24, **25**
Armory Show, 15
Arnold Comes of Age, **38**, 39, 72, 73, 79, 84, 89, 92, 93, 94, 95; photomacrograph of, **89**
Art Deco, 1, 43, 61
Art Institute of Chicago, The, 15
Arts and Crafts movement, 43
Autumn Oaks, **77**
Autumn Oaks (study), **76**

B

Batchelder, Ernest A., 43, 47–48, 55, 58, 61, 62 n. 11; *The Principles of Design*, **47**

Bauhaus, 17
Beckmann, Max, 34
Bellows, George, 43
Bement, Alon, 55
Benton, Thomas Hart, 1, 41 n. 50, 43–44, 49; *Constructivist Still Life*, **44**
Birthplace of Herbert Hoover, The, **78**, 79, 82, 84, 92, 93, 94; photomacrograph of, **86**; photomicrograph of cross section of embedded paint from, **84**
Birthplace of Herbert Hoover, The (study), **79**, 82, 92, 95
Black Barn, **58**
Booster, **30**
Braque, Georges, 19, 58
Breaking the Prairie, 80
Breaking the Prairie (study), **81**
Bunn, William, 85

C

Carnegie International Exhibition of Art, 6
Catlett, Elizabeth, 63 n. 44
Cedar Rapids, Iowa, 1, 19, 67; community theater, 58; Veterans Memorial Building, 19, 68
Coburn, Alvin Langdon, 55
Cock's-Combs, **57**
Cone, Marvin, 1, 83
Corn Room murals, 68, 74, 84, 91 n. 5, 92, 93, 94, 95
Cornshocks, **44**
Craftsman Magazine, 43, 47
Cranach, Lucas, 36
Cubist abstraction, 17
Cunningham, Imogen, 56
Curry, John Steuart, **39**; as Regionalist, 1, 41 n. 50, 43, 49; *The Tragic Prelude*, 1

D

Daughters of Revolution, 24, **26**, 74, 80, 82, 86, 92, 94, 95
Daughters of Revolution (study), **27**

Daughters of the American Revolution, 24
Davis, Stuart, 17
Death on the Ridge Road, **60**
Death on the Ridge Road (study), **61**
Degas, Edgar, 15
Delphiniums in White Vase, **53**
De Stijl, 17
Dinner for Threshers, 3, 6, **14**, 16, 17, 19, 39, 74, 79, 80–81, 82, 92, 94, 95
Dinner for Threshers (study), **15**; detail of, **16**
Dix, Otto, 20, 27, 34; *Die Eltern des Künstlers II*, **27**;
 Selbstbildnis mit Staffelei, **36**
Dove, Arthur G., 43, 56–57; *Abstraction No. 3*, **56**
Dow, Arthur W., 43, 48–49, 51, 55, 56; *Composition: A Series of Exercises in Art
 Structure for the Use of Students and Teachers*, 43, 48–49, 51, 55, 56
Dürer, Albrecht, 20, 34, 36, 41 n. 53
dynamic symmetry, 63 n. 44

E

École des Beaux-Arts, 6
Emil Frei Company, 19, 20
Eybers Jr., Carl, 68
Eyck, Jean van, 20, 23

F

Fall Landscape, 51–52, **55**
Fall Plowing, 74, **75**
Fall Plowing (study), **74**
Fauvism, 2
Feeding Time, **55**
Fénéon, Félix, 15
Fenollosa-Dow system of art education, 48–49, 51, 55, 57
Fenollosa, Ernest F., 48, 49
Four Seasons Lunettes, 67; *Autumn*, **65**; *Summer*, **64**; *Winter*, **66**
Francesca, Piero della, 6, 40 n. 14

G

Galerie Carmine, 2
German Expressionism, 20
Giotto de Bondone, 6, 15
Graham, Nan Wood, 1, 24, 41 n. 44, 83, 89
Grand Cascade Bois de Bologne, The, 2, **9**, 21

H

Hambidge, Jay, 63 n. 44
Hartlaub, G. F., 20
Haying, 3, **12**, 40 n. 8, 73, 74, 82, 86
Holbein, Hans, 20, 23

I

Impressionism, 1, 3
Impressionists, Eighth Exhibition of, 6
Indian Creek, 67, 69, 91 n. 2, 92, 95; photomacrograph of, **69**; photomicrograph of, **68**
Ingres, Jean-Auguste-Dominique, 20, 40 n. 27
Iowa Cornfield, 2, 3, **5**, 73, 76, 91 n. 12, 92, 94, 95
Iowa Landscape, **87**

J

Japanese art, 48, 49
Jewell, Edward Alden, 6

K

Käsebier, Gertrude, 55

L

Le Corbusier, 19
Léger, Fernand, 19; *Le Grand Déjeuner*, **19**
Leutze, Emanuel, 24
Lilies of the Alley (with clothespin), **48**
Little Chapel Chancelade, The, 2, **8**

M

McCray, Francis, 79

Macdonald-Wright, Stanton, 44

McKeeby, B. H., 24

March (with superimposed grid and diagonals), **61**

Matisse, Henri, 40 n. 27, 43

Memling, Hans, 19, 20, 23

Midnight Ride of Paul Revere, **xii**, 80, 85, 86, 92, 93, 94, 95; photomicrograph of cross section of embedded paint from, **85**

Millet, Jean-François, 2

Mission furniture, 46–47

Mixed Bouquet in White Vase, 51, **52**

Mixed Bouquet on a Covered Table (Flowers for Alice), **50**, 51

modernism, 43, 46, 47

Monet, Claude, 2, 3

Mott, Frank Luther, 32, 34, 41 n. 44

Munich, 19, 20, 21

N

Nach Expressionismus, 20

Nadelman, Elie, 17

Near Sundown, **59**

Neo-Impressionism, 2, 34, 39

neo-meditationists, 32

Neue Sachlichkeit, 1, 19, 20, 21, 23, 24, 34, 36, 39

"new movement," 46

New Road, 3, **13**, 40 n. 8, 73, 74

Northern Gothic painting, 1, 19, 23, 24, 36, 39

Northern Renaissance, 20, 36

notan, 49, 51

O

Oil Jar—Sorrento, **10**

O'Keeffe, Georgia, 43, 55–56; *Corn, Dark I*, **56**, 57

Old Master painting, 36, 46

Old Shoes, 91 n. 2

Orphism, 57

Ozenfant, Amédée, 19

P

Paris, 1, 2, 3, 15, 19, 20, 32, 40 n. 27

Parson Weems' Fable, 16, 17, **18**, 40, 73, 74, 76, 79, 80, 82, 86, 92, 93, 95; infrared vidicon image of, **76**; photomacrograph of, **80**

Parson Weems' Fable (study), **17**

Perfectionist, The, **33**

Picasso, Pablo, 19, 20, 40 n. 27, 43, 56, 58

Plaid Sweater, **88**

Plowing, **42**, 43, 61

pointillism, 1, 3, 36

Portrait of Nan, **ii**, 73, 85; photomacrograph of, **84**

Post-Impressionism, 1, 2, 40 n. 27

Poussin, Nicolas, 20

Pratt Institute, 55

Purism, 17, 19

Puvis de Chavannes, 15, 39

Pyle, Arnold, 39, 74, 84, 85, 91 n. 17

R

rappel à l'ordre (return to order), 19, 36, 40 n. 27

Regionalism, 1, 34, 40, 41 n. 50, 43

Renaissance art, 6, 24, 39

Return from Bohemia, 27, **29** (The Regis Collection), 34, **35** (collection of IBM Corporation), 36, 39

return to order. *See* rappel à l'ordre

"Revolt Against the City," 32, 34, 41 n. 44

Rinard, Park, 27, 34

Roh, Franz, 20, 21

Ross, Denman W., 47, 48, 62 n. 11

S

Schad, Christian, 20

Schrimpf, Georg, 20

Self Portrait, 36, **37**, 39, 41 n. 55, 73–74, 83, 91 n. 37, 92, 95;
detail of, **39**; raking light photograph of, **73**; x-radiograph of, **83**

Self Portrait (study), **36**, 41 n. 55

Sentimental Yearner, **31**

Seurat, Georges: 20, 40 n. 27; classicism of, 3, 6, 15, 16, 17, 34;
divisionist method of, 3, 15; at the École des Beaux-Arts, 6, 40 n. 14;
influence of on Wood, 1, 2–3, 6, 15–17, 19, 39; *La Pêcheuse à la ligne*, **16**;
Le Cheval attelé, 2, **4**; "scientific" color combinations of, 2;
Un dimanche à la Grande Jatte, 1, 3, 6, **15**, 17

Sheeler, Charles, 23–24; *Classic Landscape*, **23**

Single candle holder, **48**

Sloan, John, 43, 46

Smith, Pamela Coleman, 55

Song of India, 62 n. 5

Spotted Man, The, 2, **11**, 67, 74, 92, 93, 95

Spring in the Country, 79

Spring Turning, 3, **7**, 19, 39, 58, 79, 80

Spring Turning (study), 3, **6**

State University of Iowa, 27, 32

Stein, Leo, 43, 57–58

Stieglitz, Alfred, 43, 55, 57

Stone City Colony and Art School, 1, 21, 34

Stone City, Iowa, 17, 21, **22**, 23, 24, 39, 46, 72, 73, 74, 76, 82, 92, 93, 94, 95;
x-radiograph of, **82**

Stone City, Iowa (study), **21**, 58, 79, 92, 95

Strand, Paul, 56

Sultry Night, photomacrograph of, **86**, 89

Synchromism, 1, 44, 57

T

Truck Garden, Moret, **45**, 91 n. 2

U

University of Iowa, 34. *See also* State University of Iowa

W

Walker, Maynard, 41 n. 50

Weber, Max, 55

Wegner, Erich, 20, 21; *Winterlandschaft*, **21**

Woman with Plants, 89

Wood, Grant: abstract tendencies of, 46, 57; as American modernist, 43–44, 46–47,
50, 57–58, 61–62; at The Art Institute of Chicago, 15; at the Emil Frei Company,
Munich, **20**; classicism of, 6; "decorative" style of, 80; divisionist technique of, 3, 16,
17; in Europe, 1–2, 19–20, **23**, 65; farmscapes of, 58, 61; floral still lifes of, 46,
51, 57; glazing methods of, 68–69, 71–72, 84–86, 89; Impressionist paintings of, 1,
2, 3, 19, 21, 44, 67; influence of Arthur W. Dow on, 49, 51, 55; influence of Ernest
A. Batchelder on, 48, 55; influence of Georges Seurat on, 1, 2–3, 6, 15–17, 34, 39;
influence of modern French painting on, 1; influence of Neue Sachlichkeit on, 1, 20,
21, 23, 24, 34, 36, 39; influence of Northern Gothic painting on, 1, 19, 20, 24,
36, 39; with John Steuart Curry, **39;** metalwork of, 48; on modernism, 34; paint
application of, 81–86; painting materials of, 67, 68–74, 79–82, 83–86, 89–90, 91,
92–94, 96–98; plein air painting of, 2, 3, 34, 67; pointillist technique of, 2, 3, 36,
67; post-Munich portraiture of, 24, 27, 34, 36, 39; preparation and drawings of, 74,
76, 79–81; principle of "thirds" (*see* Wood, Grant, system of "thirds"); reductive
method of, 6; on Regionalism, 34; as Regionalist, 1, 24, 41 n. 50; "Revolt Against
the City," 32, 34; system of "thirds," 61, 81; technique of, 67, 68–74, 76, 79–86,
89–90, 92–94, 96–98

Wood, Nan. *See* Graham, Nan Wood

Z

Zinnias, **54**, 51